Slavery & the

UNDERGROUND

RAILROAD

in

NEW HAMPSHIRE

Slavery & the

UNDERGROUND

RAILROAD

in

NEW HAMPSHIRE

MICHELLE ARNOSKY SHERBURNE

THE
History
PRESS

Published by The History Press
Charleston, SC
www.historypress.net

Front cover: Furber-Harris House now on Cardigan School property. *Courtesy of Donna Zani-Dunkerton private collection*; Entrance statue of the Portsmouth African Burying Ground. *Courtesy of Michelle Arnosky Sherburne. Portsmouth African Burying Ground Memorial and Portsmouth Black Heritage Trail site*; Amos Fortune unsigned manumission document, 1763. *Courtesy of the Amos Fortune Collection in possession of the Jaffrey Public Library*.
Back cover, top, left to right: Nathaniel Peabody Rogers. *Courtesy of Rogers Family Collection, Michael J. Spinelli Jr. Center for University Archives and Special Collections, Herbert H. Lamson Library and Learning Commons, Plymouth State University*; Amos Fortune's compass in the Amos Fortune Collection housed at the Jaffrey Public Library, Jaffrey, New Hampshire. *Courtesy of Michelle Arnosky Sherburne and Amos Fortune Collection*; *bottom*: Lavinia's Restaurant, formerly known as Coe Mansion, Center Harbor, New Hampshire. *Courtesy of Michelle Arnosky Sherburne*.

First published 2016

Manufactured in the United States

ISBN 978.1.46711.834.7

Library of Congress Control Number: 2015954742

This book is dedicated to my parents, Jim and Deanna Arnosky, who have always been my inspiration, my source of encouragement and my pillars of strength.

CONTENTS

Contents

PREFACE

Valerie Cunningham is the founder of Portsmouth Black Heritage Trail Inc. She is responsible for the initial discovery of black heritage and slavery while researching Portsmouth, New Hampshire's history. In the book *Harriet Wilson's New England: Race, Writing, and Region*, Cunningham wrote an essay about Portsmouth's black heritage. Cunningham wrote:

> *Recent studies have shown that from the time of its earliest settlement, New Hampshire merchants, shipbuilders and seamen were active participants in the transatlantic slave trade and the slave-based economy that helped build this country. Yet these memories quickly faded as New England states removed legalized slavery from the region. By the mid-nineteenth century, the subject of slavery in New Hampshire had been reduced to anecdotes in town histories and popular publications of the day.*
>
> *In terms of population, a majority of blacks in New Hampshire had been concentrated within a twenty-mile radius of Portsmouth since 1645. In 1760, enslaved black workers accounted for 4 percent of Portsmouth's population, about 160 people out of 4,000. As Portsmouth's African American population grew older, its numbers became smaller, and as the people disappeared, stories of "slavery days" seemed to vanish with them. Of course, it is precisely this very "forgetting" in town histories and records that resulted in the loss of black heritage altogether.*
>
> *Slavery was not abolished in New Hampshire in a bold obvious move, such as Vermont's claim of being the first state to do so. It wasn't until*

1857 that the legislature enacted an equality ruling that "no person, because of descent, should be disqualified from becoming a citizen of the state." This act has been accepted as abolishing slavery, but technically it didn't come right out and do so. New Hampshire wasn't legally cleared until the Thirteenth Amendment in 1865 abolishing slavery in the country; the state ratified it on July 1, 1865.

The international slave trade in the United States ended in 1807, which altered Portsmouth's shipping industry of importing slaves. Regardless, most slaves were manumitted by their owners one by one, perhaps because the declining postwar economy could no longer provide enough business to offset the financial burden of maintaining unpaid laborers in the household.

As slave labor was routinely replaced by low-wage white workers, former slaves and their descendants in New Hampshire were perceived by non-blacks to be part of the social and economic servant class that would eventually include all black Americans. White America defined servants as Negroes and Negroes as servants. This attitude continued for at least a century after Harriet Wilson wrote the novel Our Nig; or, Sketches from the Life of a Free Black. African Americans were competing with the newest wave of immigrants for the most menial jobs or were reinventing themselves as entrepreneurs, working as day laborers or laundresses, cooks or caterers, mariners or landlords, footmen or truckers, maids or seamstresses.

In 1857, New Hampshire officially declared itself to be a "free state." Portsmouth's role in the Atlantic slave trade and slaveholding was being erased from public memory. Slaves and their owners were no longer mentioned in the publications of the day. The emphasis had shifted from ownership of slaves to their representation in more stereotypical, childlike guise. Non-blacks in New Hampshire seemed only too willing to forget the complicity of the founding fathers and their own economic dependence on the slave-based economy. References to the presence of slaves were typically modified by declaring that there never had been very many or that a black "servant" complemented the elegant lifestyle of the "master."

At the turn of the twentieth century, while the South romanticized its pre–Civil War relationship with slavery, most of New England denied ever having such a past. Until recently, New Hampshire may not have remembered its own history, but as the stinging reality of the 2003 unearthing of a black cemetery under a Portsmouth street shows, that history is surfacing more forcefully all the time.

PREFACE

Discover Portsmouth director JerriAnne Boggis is the founder of the Harriet Wilson Project in Milford, New Hampshire. In her essay published in *Harriet Wilson's New England*, Boggis wrote about the black history in the town she lived in for years. Boggis wrote the following:

One never had to look too far or search too hard for signs of his white history, his heritage. It is written. It is visible. It is concrete. It is a story that is told and retold in the books my sons have read in school since they were six. It is the story of our state that is told and retold through the ubiquitous images of verdant hills, a pastoral setting and a pure Anglo-Saxon lineage.

And that was how I discovered that Harriet E. Wilson, the first black woman to publish a novel in the United States and the author of **Our Nig: or Sketches from the Life of a Free Black,** *was born and raised here in Milford, the town I've lived in for more than 23 years.*

And as I read, an unimagined and more complex picture of our town's history began to form. The myths I had accepted began to crumble. First, Milford's history was not "lily-white."

As truth has been revealed by historic discoveries in recent years, New Hampshire was not either. Who was responsible for this whitening of history?

The second myth that would fade away was the belief that our town, like the rest of the North, had been a safe haven for blacks and that its inhabitants were kinder than their Southern counterparts.

But here was a second story of our town, a story that could have come from the slaveholding South. I was horrified by the extent of brutality Frado experienced and was even more dismayed that sympathetic observers had not intervened on her behalf. Wilson showed just how easy it is to be invisible in plain sight.

It was yet another sign of America's reluctance to address the history of abuse and oppression when that abuse and oppression were directed at its own minority groups. We see this historical amnesia around the treatment of Native Americans, Asians (including the Japanese Americans who were held in detention camps during World War II), Latinos and African Americans.

However, history has shown us how simple it is for African Americans to disappear from the records of a town and the collective memory of a community.

The fabrication of an all-white state wiping out a more "color-filled" history was perpetuated. The attempt worked until history revealed itself. The reality [is] that there is a black heritage that dates back 360 years with the arrival of the first African immigrant—an immigrant, albeit unwilling.

Preface

To sum it up simply, there is a final line in the play *Hearing from Harriet* that was performed in commemoration of the Harriet Wilson Project's celebration unveiling the Harriet Wilson statue in 2006: "I was here."

Blacks, slave and free, were here in New Hampshire.

Excerpts used by permission of Cunningham and Boggis, from *Harriet Wilson's New England: Race, Writing, and Region*, edited by JerriAnne Boggis, Eve Allegra Raimon and Barbara A. White (University of New Hampshire Press, 2007).

ACKNOWLEDGEMENTS

I would like to take this opportunity to express my gratitude to those who have helped me in this project. It has been an incredible journey to discover the fascinating people and stories in connection with the Underground Railroad, New Hampshire's slavery and the black heritage recently revealed.

I hold in high esteem the work of Valerie Cunningham, Henry Louis Gates Jr., JerriAnne Boggis, Barbara White, David Watters, Reginald Pitts, Craig Steven Wilder, Mark Sammons, Jody Fernald and Stephanie Gilbert. I am grateful for Peter Lambert's research efforts about Amos Fortune; Eric Lauritsen's work on New Hampshire's slave trade; Toni Feeney's website on the 1700 census in New Hampshire; and Heather Wilkinson Rojo's research.

Thanks to the great staff at New Hampshire and Vermont libraries: Dartmouth College's Rauner Special Collections Library, especially Caitlin Birch; Luisa Lindsley at Tenney Memorial Library, Newbury; Libby Fell, library director at Jaffrey Public Library; Alice Staples at Lamson Library at Plymouth State University; Lyme Historical Society and Museum; Nancy Meyers at Haverhill Library; and Littleton Public Library.

Also, special gratitude is expressed to Priscilla Power, Charlie Balch, Laurie Wadsworth and Donna Zani-Dunkerton of Canaan Historical Society; Bob Adams, owner of the old Haverhill jail; Steve Restelli, former owner of the 1862 Lebanon journal and the late Richard Henderson for his research; and Roland Garland at Center Harbor Historical Museum.

New Hampshire is fortunate to have Discover Portsmouth promoting its history and Strawbery Banke for the invaluable work of restoring and

preserving Portsmouth's history and architecture. Thanks to the Portsmouth Black Heritage Trail Inc., Portsmouth's African Burying Ground Memorial, the Harriet Wilson Project Black Heritage Trail and Amos Fortune Forum for educating about and perpetuating the state's history.

If it wasn't for Betty Johnson Gray, the owner of Bliss Tavern in Haverhill, and her love of history, this journey would not have begun. My first foray into the Underground Railroad history was a newspaper feature story on Gray's home. From the first time I met her, Betty has been an inspiration.

I would be remiss not to honor Wilbur Siebert, who was the forerunner of Underground Railroad research, and his endless efforts reaching out to people about the subject. Thanks to Ohio Historical Society and the Siebert Collection.

My history quests would not be possible if it weren't for my husband, Rodney; my son, Darren; and my friend and employer Connie Sanville. No words can express my gratitude.

God is good, all the time, and has sustained me throughout this project.

INTRODUCTION TO NEW HAMPSHIRE'S HIDDEN HISTORY

Researching the Underground Railroad is always a challenge for a number of reasons. The nature of the network was secrecy, and the lack of documentation of people's efforts to help fugitive slaves on their escape journeys makes it difficult. The other obstacle stems from the local histories that were written in the late nineteenth century that overlooked or ignored Underground Railroad contributions.

In the same vein, New Hampshire's slavery and black heritage was lost because people wanted to paint an image of pioneers and heroes, not slave owners. After the Civil War and our country's Reconstruction era, people wanted to move forward and not focus on the past. War heroes were celebrated in town histories, but dredging up anything connected to the slavery era was bypassed. People in the North and South were trying to forget that bad part of the country's past. If it was not talked about or recorded, it would eventually fade away. So these histories and the records of the nineteenth century were edited to downplay anything negative.

The problem with irresponsible recording of history is that an illusion is created and then shared over and over. The fabrication of New Hampshire's white history minus slavery and any efforts to help fugitive slaves is accepted and taken at face value.

The interesting twist about history is that somehow the truth comes through, even if it is two hundred years later. This is the case regarding a

book published in 1859 by an African American woman, Harriet Wilson, who was a black indentured servant for a Milford family, or the thirteen coffins unearthed under Chestnut Street in Portsmouth that were part of a black cemetery.

New Hampshire did have a hidden history because historians downplayed the history of slavery and black heritage. Collectively, New England tried to claim it was always sympathetic to the slaves' oppression and always antislavery. If New Englanders really embraced blacks and former slaves in their communities, why was it so hard to find any trace of them? If they were equals, why did historians choose to omit their contributions and records of their lives?

Francie Latour stated it so well in a *Boston Globe* article on September 26, 2010:

> *When it comes to slavery, the story that New England has long told itself goes like this: Slavery happened in the South, and it ended thanks to the North. Maybe we had a little slavery, early on. But it wasn't real slavery. We never had many slaves, and the ones we did have were practically family. We let them marry, we taught them to read, and soon enough, we freed them. New England is the home of abolitionists and underground railroads. In the story of slavery—and by extension, the story of race and racism in modern-day America—we're the heroes. Aren't we?*

I can't convey the thoughts any better. This attitude exudes from the erasure of New Hampshire's real history.

Joanne Pope Melish, associate professor at the University of Kentucky, wrote that the "campaign to remove former slaves and their descendants from their [whites'] landscape and memory" was prevalent in New England and was a deliberate "symbolic removal of people of color from their place in New England history." It is shameful that an entire state's history was the result of deliberate whitewashing.

History is the good, the bad and the ugly. There is no sugarcoating it to make it easier to accept. People, events, accomplishments, etc. should be reported as they occurred, not rewritten. Selective editing is a disservice to future generations. It is the responsibility of historians to be respectful of evidence in history and retain it to share, not edit it to protect posterity from bad news.

Slavery existed in New Hampshire from the time it was settled in the 1600s. Blacks were responsible for contributing to the history of New Hampshire.

New Hampshire was not built on the backs of white Puritans; it was built on the black immigrants who were brought here unwillingly.

After two hundred years of fabricated history, New Hampshire can celebrate the contributions of those who were lost in obscurity. They are not forgotten—the slave, the free black, the courageous Underground Railroad agent, the fugitive slave. They have been found.

Part I

NEW HAMPSHIRE'S SLAVERY

Chapter 1
SLAVE TRADE

For decades, Portsmouth has promoted its historic grandeur from its seventeenth-century settlement and the incredible history and architecture that have been preserved. What was not highlighted until the twenty-first century was Portsmouth's major role in the slave trade. Thanks to the work of Valerie Cunningham, Mark Sammons and Eric Lauritsen and recent archaeological discoveries, the truth has surfaced: not only did New Hampshire have slavery within its borders, but Portsmouth was tied to the transatlantic slave trade.

In *Black Portsmouth*, Sammons and Cunningham stated, "New Hampshire ships carried many Africans to the Caribbean, Virginia, and Portsmouth."

Dartmouth College graduate Eric Lauritsen conducted extensive research for his history honor thesis in 2009. "The Untold Story of New Hampshire and the Transatlantic Slave Trade: 1700–1800" shed light on New Hampshire's slave trade. Lauritsen wrote:

> *Why are all the facts of the relationship between New Hampshire and the slave trade not widely known by the keepers of New England's history? The answer can probably be traced back to Jeremy Belknap, founder of the Massachusetts Historical Society and author of New Hampshire's first comprehensive colonial history…Belknap excluded any mention of New Hampshire's involvement in the trade in this otherwise highly comprehensive work. Subsequent historians of New Hampshire through the first part of the nineteenth century similarly failed to inventory its involvement, and in*

so doing, strengthened the foundations for an artificially whitewashed and sanitized account of the state's beginnings.

In 1696, there was a revocation of the charter of the Royal African Company, which had a monopoly on the slave trade; this opened up the slave trade to any country. Portsmouth merchants saw the opportunity to get involved in this lucrative business. With the city's shipbuilding industry, there were many ways to capitalize on the slave trade that would enrich the economy in Portsmouth. Between 1728 and 1745, Portsmouth captains traveled to Guinea, Virginia and Barbados with orders to bring back slaves to sell. New Hampshire slave voyages were heading to Guinea ports along the Gambia River and the Cape coast. Barbados, South Carolina and sometimes New Hampshire itself served as the principal markets for the New Hampshire slave traders.

The images of slave ships and the illustrations of five hundred people packed below decks of the ships does not illustrate what New Hampshire slavers were like. Generally, New Hampshire slavers were fast ships that would make trips quicker, but the slave cargoes were smaller. The vessels were usually 120 tons, not the typical 200-ton ships used specifically for slave voyages. These slavers carried fewer than one hundred slaves in addition to all the West Indies imports they were transporting. The smallest voyage from New Hampshire was in 1758 from the coast of Africa and returning to Portsmouth with only eighteen slaves on board.

New Hampshire merchants probably dabbled in the transatlantic slave trade as a supplement to their trade in fish, lumber and other goods for import like salt, sugar and molasses in mainland North America, the Caribbean and Europe.

New Hampshire's participation in transatlantic slave voyages came as a result of business connections with merchants and captains outside the colony who were frequent slave traders. The first period with multiple New Hampshire voyages was around 1730, when five voyages departed the colony in a five-year period.

In his studies, Lauritsen analyzed where slave ships were registered, their port of departure and their ports of sale. He summarized that there were six ships registered in New Hampshire that departed from Portsmouth between 1729 and 1804. Ports of sale listed were Barbados, West Indies, Portsmouth, Tortuga, South Carolina, Grenada and Argentina. Some voyages had as few as 18 slaves and as many as 273 slaves on board.

He wrote, "Most ships with New Hampshire registration probably belonged to New Hampshire merchants, and thus slave voyages on such

ships generally represent the investment of merchants within the colony. The port of departure usually serves as a strong indicator for where the investment in the voyage was centered and where the cargo originated."

A major source of information that survived the apparent erasure of the New Hampshire slave trade was the advertisements in Portsmouth's first newspaper, the *New Hampshire Gazette*, starting in 1756. They reported voyages from the customs house as well as ads for slave sales.

Portsmouth captains who participated in the slave voyages were Samuel Moore, Joseph Bayley, John Odiorne, John Major, Thomas Dickerson, Benjamin Russell, William Rhodes Campbell, Samuel James, Nathaniel Tuckerman and David Harrison. Ship owners included John Moffatt, William Whipple, Joseph Whipple, George Meserve, Samuel Moore, Joshua Pierce, Pierce Long, John Rindge, Robert Traill and J. & S. Wentworth. Following are the ships that were registered in New Hampshire and specifics about each.

Black Prince was a forty-ton schooner registered in New Hampshire and owned by three prominent Portsmouth businessmen. William Whipple had served as a general in the Revolutionary War and was one of the Declaration of Independence signers. Joseph Whipple was appointed by President Thomas Jefferson to serve as collector of customs for Portsmouth and was involved in the attempts to recover President George Washington's runaway slave, Ona Judge Staines. George Meserve, a Portsmouth merchant, was involved in local government.

The *Black Prince* captain was Caleb Gardner Jr., a well-known slave captain who was based out of Rhode Island but may have lived a while in Portsmouth. Lauritsen wrote, "The fact that Gardner, one of the top slave captains of the day, would even command a New Hampshire voyage in the first place is telling in itself; clearly Portsmouth was seen as a viable port through which to conduct a slave voyage by individuals with deep ties to the trade."

He continued, "The *Black Prince* arrived in Barbados in March 8, 1764 with 145 slaves taken from an unspecified African port. This makes it one of the largest shipments of slaves in any voyage in which New Hampshire was a direct participant. After selling 25 slaves in Barbados, the Black Prince proceeded to South Carolina, where it sold the remainder of its cargo."

Gambia's voyage of 1732 was an eventful one that ended in the captain's murder. While Captain John Major was trading along the Gambia River, a group of Africans who were traders selling to the Americans revolted and killed him.

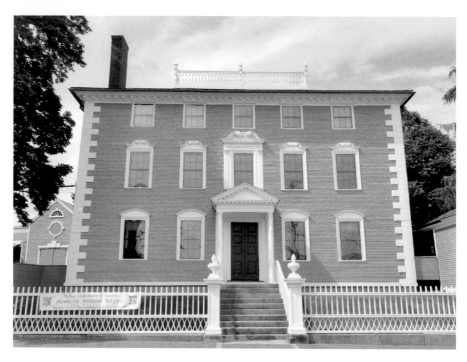

The Moffatt-Ladd House on Market Street, Portsmouth, was the home of William Whipple, one of the signers of the Declaration of Independence. Whipple and another house owner, John Moffatt, were also ship owners who imported slaves. Prince, Dinah, Cuffee, Rebecca and their children were slaves in this house. *Courtesy of Michelle Arnosky Sherburne, the Moffatt-Ladd House. Portsmouth Black Heritage Trail site.*

In Francis Moore's *Travels into the Inland Parts of Africa*, one of the Africans who interacted with Major stated, "I did not say much to the Captain, but came home, called all my People together, told them the Case, and then we reckon'd up the many Injuries we had received from other separate Traders, and at last we resolved to take the Scooner, which we did the next Morning. In the Action the Captain was killed, for which I am very sorry."

When word of Major's death made its way back to the colonies a few months later, newspapers as far away as South Carolina carried the story.

Lark, commanded by Thomas Dickinson, departed from New Hampshire in May 1732. A listing of the income received from the taxes and duties from Barbados's slave and liquor imports for the first quarter of 1733 indicates that thirty slaves were unloaded on that island. Lauritsen states that though thirty slaves were reported, it was probably a fraction of the slaves the *Lark* carried across the Atlantic, as New Hampshire's African voyages often traded slaves in multiple ports.

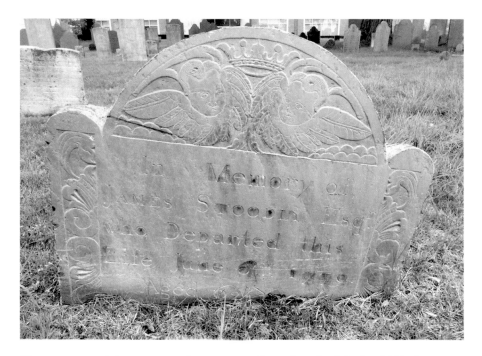

The gravestone of slave owner and tavern owner James Stoodley is in the old North Cemetery on Woodbury Avenue. *Courtesy of Michelle Arnosky Sherburne.*

The ship *Pocock* left in October 1763 from Portsmouth and stopped in Jamaica before its departure to Africa. Shipping records maintained by colonial British traders at the Cape Coast Castle in Africa indicate that the ship arrived there on January 15, 1764, and boarded one hundred slaves. Upon departing the Cape Coast Castle on July 2, the *Pocock* proceeded to Barbados, then to Havana and finally to South Carolina to sell its cargo.

Captain Andrew McKenzic Sr.'s 1773 voyage on *Friendship* departed Portsmouth in the summer of 1772 for the coast of Africa. He spent a few months in Africa, trading 165 slaves along the Gold Coast before setting sail on his return to North America. The first port was Barbados, and then the *Friendship* sailed for South Carolina, where McKenzie sold 140 slaves.

The forty-ton sloop named *Fyall* was owned by John Moffatt (or possibly Robert Traill). Captain David Harrison's 1758 voyage on the *Fyall* was scheduled for a quick trip. The *Fyall* journeyed to Gambia River, picked up eighteen slaves and returned to Portsmouth to sell them. An advertisement ran in the *New Hampshire Gazette* on August 11, 1785, for the sale that took place on a neighboring ship, the *Carolina*, owned by Traill. The ad reported, "Likely Negro Boys and Girls just Imported

from Gambia, and to be sold on board the Sloop 'Carolina' lying at the Long Wharff in Portsmouth."

Exeter, owned by John Moffatt and captained by Benjamin Russell, sailed from Moffatt Wharf in Portsmouth for Africa on November 13, 1755. Russell's log was preserved, and one of the pages marks the inventory of the ship itself, which includes—in addition to gold, tobacco and other items— "Twenty men Slaves, Seven Man boy do, Ten Boy do, Fifteen Women do, Two Woman Girl do, Seven Girl Do."

Captain Nathaniel Kent sailed the *Hannah* from Portsmouth in 1764 and returned to Portsmouth to sell fifty-four slaves. Kent was an active captain in the port of Portsmouth, serving as commander for numerous voyages in and out of Portsmouth.

The *Mermaid* originally departed out of Portsmouth in 1771 under the command of Andrew McKenzie Jr. McKenzie and his father, Andrew Sr., were well-known slave captains, each serving as master of at least two separate voyages to Africa out of the colony. They worked as a convoy, traveling and trading together. The first of these was in August 1770 with the son on the *Mermaid* and the father on *Friendship*.

Besides ships, ship voyages and slaves, New Hampshire's economy in the seventeenth and eighteenth centuries benefited from the transatlantic slave trade because of the resources exported from the Granite State that were indirect connections.

New Hampshire's shipbuilding industry dates back to 1641. By 1713, shipwrights in the Portsmouth area were constructing vessels of 130 tons or more. Overall output of ships built in New Hampshire went from forty in 1727 to eighty-two by 1742. Lauritsen reported that "shipbuilding would remain a significant contributor to New Hampshire's economy through the remainder of the colonial era, though it would be hurt by the same factors that damaged the mast trade in the 1760s."

Lumber alone was a huge export from the mountainous, heavily wooded New Hampshire counties. By 1665, over twenty sawmills along the Piscataqua River alone were in operation, and that number increased into the seventeenth century. Dutch and English shipbuilders found the white pine masts from New Hampshire and other northern New England locations very desirable as early as the 1630s. Masts and pine boards were sold for large profit to England, the Azores, Madeira, the Canaries and southern Europe. By the 1740s, England had become the primary trading partner in New Hampshire's mast trade.

The British West Indies imported the state's timber products like staves; clapboards; pine boards; naval stores such as pitch, tar and resin; and other

goods used in shipbuilding. New Hampshire also exported house frames, axes, pails and wheelbarrows.

In direct connection to the slave trade was the export of refuse codfish. The codfish from the Piscataqua River was shipped in large quantities to the West Indies because it was the primary food given to African slaves awaiting export.

Chapter 2
SLAVES IN NEW HAMPSHIRE

Unlike other New England states, the existence of slavery in New Hampshire wasn't a result of early settlers who brought one or two to town. It was in full force up through the 1800s, involving buying and selling slaves. Though the slave population numbers were small in comparison to southern states, slavery existed in the Granite State. Nineteenth-century written accounts about slaves downplayed their status to that of servants who were part of the family. It is insulting the way blacks in nineteenth-century texts were referred to as curiosities and their life stories labeled as anecdotes or miscellaneous. Too often in the town histories, an account of slaves was followed by "entertaining anecdotes" like a story of an annoying bear.

An example of the low regard held for blacks was the 1776 Continental Congress resolution calling New Hampshire residents to enlist to fight in the Revolutionary War. Though hundreds of slaves fought for our nation's independence, the derogatory references about blacks in the notices circulated through the colonies stated, "All New Hampshire selectmen requesting all males over 21 (with exceptions of lunatics, idiots and Negroes) to sign up to promise that we will to the utmost of our power, at the risk of our lives and fortunes with arms oppose the hostile proceedings of the British fleets and armies against the United American Colonies."

The tone used in references to blacks in New Hampshire histories was condescending. Terms frequently used were "well remembered," "a character," "slave had excellent manners," "was high spirited," "claimed

to be a prince" and "who by his own account, supported himself." These references convey the attitude of northerners.

In *Rambles of Portsmouth*, Charles Brewster's chapter on slaves was written as an entertaining glimpse of slave life. "Entertaining" is not appropriate regarding accounts of slaves.

The majority of town histories referred to slaves or slavery in terms of census figures. Sometimes they were not even mentioned separately but only in the list. For example: "list of males under 16, males over 20, females, Negroes or slaves."

A perplexing reference to slave ownership is in the *History of Piermont, New Hampshire, 1764–1947* because of the way it was worded: "The question of slave ownership in Piermont has intrigued us, and we were most pleased to find in the Archives of the Baker Library at Hanover this bill of sale." The receipt is then printed for Lucy, a slave sold by a Piermont man.

Reviewing census records for the New Hampshire counties shows that the number of slaves in one household was as little as one or two. Sometimes the census had only one or two slaves registered in a town. If you were the only slave in Hinsdale and everyone else was white and free, you were alone.

The misconstrued concept that northern slavery was easier and not really "slavery" is erroneous. In reality, a slave in New Hampshire was the same as a slave in New York, Connecticut, Virginia or Kentucky. A slave had no free will, no rights, no choice. A slave was not an employee who could go to his own family and home at the end of the day.

"As it existed in this province, including Concord, it was a mild form; and the treatment of slaves was generally humane, and their labor not more severe than that of white people," Nathaniel Boutin, a Concord historian, wrote in the *History of Concord*. The references to "mild form" and "generally humane" are prime examples of watering down the actuality of slavery. Boutin editorialized that "in Concord though the slaves were few, and the masters merciful, yet strange to the philanthropic sense of to-day seem the deeds of sale by which property in human chattel was then transferred." In essence, it was a feeble attempt to justify to his nineteenth-century readers that selling slaves back in "the old days" was not a big deal even though bills of sale would be as offensive to his readers as they are today.

A *Valley News* article on February 8, 2008, stated:

> *While 18th century Northern slavery did not look like its Southern counterpart—slaves lived in the house with their masters and many were encouraged to learn to read and allowed to carry weapons for protection*

from attacking natives—it was slavery nonetheless. That part of the region's history, and the difficulties for freed or escaped slaves that followed, were perhaps simply easier forgotten after the Civil War's bloody struggle.

Slaves in New Hampshire were few in number, which meant a lonelier existence. Most slaves were working in the homes or businesses of owners. Those owners who were not as affluent probably worked alongside their slaves.

In the *Rambles of Portsmouth* by Charles Brewster, a street map has the Negro Burying Ground designated off Chestnut Street. By the mid-1800s, the cemetery was eliminated from maps and, thus, erased from Portsmouth memory. *Courtesy of* Rambles of Portsmouth.

It probably was more psychologically abusive being in proximity with the white owners. There was little respite from their owners. Northern slaves slept in available spaces in the house—in the attic, ell or cellar. They didn't finish their day and head to the slave quarters away from their owner or overseers. They didn't have a place where they could retreat and be with their own people. They were always on guard, always afraid and always slaves.

In the 1790 census for New Hampshire, there is a category labeled "New Hampshire Slave Holders, Other Free Persons and Slaves." Researcher Toni Feeney has the detailed information on the 1790 census website, including small biographies of names listed. Reviewing the towns in the New Hampshire counties, the census reports on the slave owners and the slave count per town. Granted, not every slave was registered on the census.

It is important to see the numbers, though small, to understand that all over the state of New Hampshire, slavery was active as late as this census date. The town tallies also show that as far north as Grafton County—which is considered northern New Hampshire—slaves were owned; it did not just occur in the seacoast towns. Following is a breakdown of the numbers of slaves by county and town.

In Strafford County: Barnstead, one owner, one slave; Dover, six owners, eight slaves; Durham, three owners, three slaves; Effingham, one owner, one slave; Gilmantown, one owner, one slave; Moultonborough, one owner, one slave; Rochester, one owner, one slave; Somersworth, three owners, four slaves; Tamsworth, one owner, one slave.

In Rockingham County: Brentwood, one owner, one slave; Canterbury, one owner, three slaves; Concord, three owners, four slaves; Deerfield, one owner, one slave; Epping, five owners, five slaves; Exeter, one owner, two slaves; Greenland, two owners, two slaves; Hampton, one owner, one slave; Hawke, one owner, one slave; Londonderry, five owners, five slaves; Loudon, two owners, two slaves; Newington, nine owners, fourteen slaves; Newmarket, one owner, one slave; Newtown, one owner, one slave; Northwood, one owner, one slave; Nottingham, seven owners, twelve slaves; Pembroke, two owners, two slaves; Poplin, one owner, one slave; Portsmouth, seventeen owners, twenty-six slaves; Rye, two owners, three slaves; Stratham, one owner, one slave; Windham, three owners, five slaves.

In Grafton County: Bartlett, one owner, one slave; Bath, one owner, one slave; Bridgewater, one owner, one slave; Campton, one owner, one slave; Hanover, one owner, two slaves; Haverhill, two owners, four slaves; Orange, one owner, one slave; Orford, one owner, three slaves; Piermont, three owners, three slaves; Plymouth, one owner, four slaves.

In Cheshire County: Charlestown, one owner, one slave; Claremont, two owners, two slaves; Cornish, one owner, one slave; Hinsdale, two owners, four slaves; Keene, two owners, two slaves; New Grantham, one owner, one slave; Newport, one owner, one slave; Protectworth, one owner, one slave; Walpole, two owners, two slaves; Westmoreland, one owner, one slave; Winchester, one owner, one slave.

Due to space constraints, we can only scratch the surface of the slaves who were in New Hampshire. Though former historians tried erasing their existence, in the twenty-first century, we know there were large numbers of slaves in the state. Scratching the surface doesn't do justice to the lives of the enslaved here in New Hampshire.

A review—not at all the extent of what should be on record—follows with proof of ownership through slave bills of sale; examples of slaves in some New Hampshire towns.

North Conway

Gordon Tasker Heard, author of *The Hotels of Intervale*, wrote that Colonel Andrew McMillan of North Conway owned twenty slaves. That was a lot of slaves for a hotel owner that far north.

Nottingham

Another example of the low slave population numbers is shown in Nottingham. The population in 1775 was 983 whites and only 16 "Negroes and slaves for life." It should be noted that the slaves in the area were not all blacks; some were Native Americans in bondage.

Piermont

A bill of sale could be found: "Lucy, negro wench, twenty-two years old, married, sold by Benjamin Patterson of Piermont to Ebenezer Brewster of Hanover, May 10, 1781, for 50 pounds."

Exeter

History of Exeter has a chapter about slaves who were in town and highlights the Revolutionary War veterans among them. The opening paragraph is worth noting:

> *The colored population of Exeter has always been more considerable, proportionally, than that of other country towns in New Hampshire. In colonial times the wealthier inhabitants held slaves, whose descendants remained domesticated in the place, and intermarried with others, so that their numbers have been well kept up. Several of them fought for their liberties in the War of the Revolution.*

It was customary to require all marriages to be recorded in town records, even for the slaves. Listed in *History of Exeter* are "Negro" marriages dating from 1777 to 1823. In the 1775 census, the slave count was 38 of more than 1,700 residents.

Exeter population totals of slaves were: fifty slaves, 1767; thirty-eight slaves, 1775; two slaves, eighty-one freed slaves, 1790. By 1790, all but two slaves had been freed in Exeter, although some freed may have stayed in the service of their households longer. In 1790, the largest free African American population in New Hampshire lived in Exeter. By 1900, there were only thirty African Americans living in town.

Concord

The following is from N. Bouton's *History of Concord*:

> *That slaves were bought and sold like cattle and horses, previous to the Revolution, appears from the following, taken from the* Essex-Journal, *(Newburyport) March 2, 1774:*
> *"To be sold, a Healthy Negro Girl, about twenty-three years old—born in this country. Likewise, a Serviceable Mare, which goes well in a carriage. Enquire of the Printers."*

In the 1767 census, it was recorded that Concord had 752 inhabitants, including 9 male slaves and 4 female slaves. But in the town histories, slave ownership was downplayed drastically.

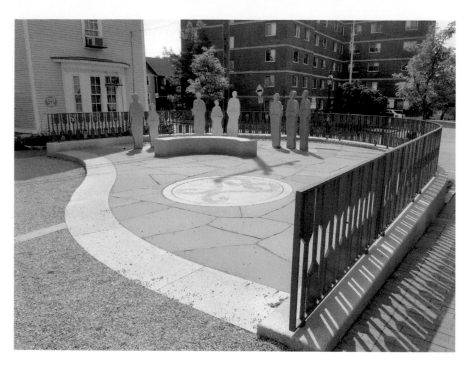

The Portsmouth African Burying Ground has the burial vault lid, the circle pictured on the ground, with the Adinkra symbol on it. The vault contains the reinterred remains of the coffins exhumed in 2003. The semicircle of community figures are life-sized bronze silhouettes representing the community of Portsmouth. *Courtesy of Michelle Arnosky Sherburne, Portsmouth Black Heritage Trail site.*

On record is Concord resident Colonel Benjamin Rolfe's will, which had two specific provisions in regard to his slave Pompey. Rolfe requested of his executor that his slave, who was part of his property, be given to his grandson. The condition was for the executor "to take especial care that my said negro be not wronged by my aforesaid grandson in any way; and if he should wrong him, I give him power to do him justice." The other condition in the will was that Pompey was given half an acre of land for the rest of his life. It is interesting to note that Pompey was able to have his own land but he did not have his freedom.

Recorded in *History of Concord* are the following bills of sale. The first is dated May 24, 1768:

> *Know all Men by these Presents That I, Patrick Gault of Chester, in His Majesty's Province of New-Hampshire, in New-England, husbandman, for and in consideration of the sum of twenty pounds, lawful money, to me in hand before the delivery hereof, well and truly paid by Andrew*

*McMillan, of Concord, in the Province aforesaid, Esq., the receipt whereof
I do hereby acknowledge, have bargained and sold, and by these presents do
bargain and sell unto him, the said Andrew McMillan, my Negro Garl,
named Dinah, aged about eight years, to have and to hold the said Negro
Garl Dinah, by these presents to him, the said Andrew McMillan, his
heirs, administrators and assigns; and I, the said Patrick Gault, for myself,
my heirs and administrators, shall and will warrant and forever defend
her, the said Negro Garl, unto him, the said Andrew McMillan, his heirs,
administrators and assigns, against all the claims and demands of any
person or persons whomever; and have put her, the said Negro Garl, in his,
the said Andrew McMillan's possession, by delivering her unto him, the
said McMillan, at the time of sealing hereof. In witness hereof I have here-
unto set my hand and seal, this 24th day of May, and in the eighth year
of His Majesty's reign, A.D. one thousand seven hundred and sixty-eight.*

In presents of us: Hannah McMillan, Sam'l Noyes.

Patrick X [his mark] Gault.

The following deed was dated 1767 at Concord:

*Received of Andrew McMillan, the sum of forty-seven pounds ten
shillings lawful money, in full consideration for my negro boy slave named
Caesar, aged about eleven years, which negro boy I have this day sold to
said McMillan, and promise to warrant and defend the property of the
said negro boy to him the said McMillan, and his heirs or assigns forever,
against the claims of any other person or persons whatsoever.*

This bill of sale was from Billerica on May 2, 1761:

*Know all Men by these Presents, That I, Hannah Bowers, of Billerica,
widow, have sold unto Lot Colby, of Rumford, in the Province of New-
Hampshire, a mulatto Negro Boy, named Salem, and have received forty-
five shillings sterling, in full consideration for the said boy, as witness my
hand. Teste: Joseph Walker, Josiah Bowers*

Hannah Bowers

The copy of a slave bill of sale was published in the January–June 1906
issue of *Granite State Magazine*: "June 3, 1777 Robert Lapish of Durham,
joiner, paid six pounds to Jacob Sheafe of Portsmouth for a slave named
Joseph who was about thirty-seven years old."

Durham

The best documents located are the manumission or freedom papers for slaves. In Durham, slave owner John Woodman manumitted his slave Daniel Woodman in 1777. Daniel had fought in the Revolutionary War and was granted his freedom after the war on June 23, 1777. The conditions of his freedom were for Daniel to reach twenty-eight years old and pay sixty pounds, which he did. After the war, he changed his name to Dan Martin. He worked on the freight boats that were sent to Portsmouth. He received a pension for his service when he was sixty-eight years old. He had a family and property and, most importantly, his freedom. He died in Greenland in 1839.

The following is Daniel Woodman Martin's "liberation paper":

> *Know all men by these presents that I, John Woodman, of Durham in the county of Strafford and State of New Hampshire, yeoman, for and in consideration of the sum of sixty pounds lawful money to me in hand paid*

The Samuel Penhallow House is on Strawbery Banke and is part of the Portsmouth Black Heritage Trail. Samuel Penhallow was a justice of the peace, and slaves and free blacks came to this house to register and get the necessary paperwork to confirm their status. *Courtesy of Michelle Arnosky Sherburne, Strawbery Banke property and Portsmouth Black Heritage Trail site.*

before the delivery hereof by my negro man Dan, a servant for life, about twenty-eight years of age, the receipt whereof I do hereby acknowledge, have given, granted, bargained & sold & by these presents do give, grant, bargain and sell unto the aforesaid Dan his time for life, liberating & making him a free man to all intents as tho' he had been born free, hereby engaging for myself, my heirs, exec ra & adminra that no person or persons claiming from, by or under me or them shall have any right to demand any service of him in future as a slave. In witness whereof I have hereunto set my hand & seal this 23d day of June Anno Domini 1777. Signed Sealed & delivered JOHN WOODMAN. in presence of JOHN SMITH, Jona. CHESLEY.

Hanover

The first slaves in Hanover were brought to town by the founder of Dartmouth College, the Reverend Eleazar Wheelock. John King Lord wrote in *A History of the Town of Hanover, N.H.*, in 1928: "There were a number of negro slaves held in Hanover in the early days. The census of 1767 mentions none; apparently the first were brought here by Dr. Wheelock, including Brister, Exeter and Chloe, his wife, Caesar and Lavinia, his wife, Archelaus and Peggy." The following chapter deals with slaves and Dartmouth College in this town.

DARTMOUTH COLLEGE AND SLAVES

I t seems ironic that Dartmouth College, originally a mission to evangelize and educate the population of Native Americans in New Hampshire, was actually built on the backs of enslaved blacks. Many American colleges were established in the 1700s in the same way.

Craig Steven Wilder, history professor and author of *Ebony and Ivy: Race, Slavery and the Troubled History of America's Universities*, extensively researched our country's universities and the subject of slavery. He delved into the histories of Dartmouth College, Yale and Princeton, for example, where slave ownership was the norm among the founders.

Former Dartmouth College president James Wright stated on Joseph Asch's dartblog.com: "Slavery was deeply embedded in all our institutions, which found ways to explain and rationalize slavery, even after the formation of the American republic."

Dartmouth's founder, the Reverend Eleazar Wheelock, had a dream and a mission to educate the Native Americans in the wilderness of New Hampshire. He arrived in Hanover in 1769, having received a charter of land along the Connecticut River. Along with his family, he brought eight slaves.

In the 1600s, the concept of Indian colleges was to convert and educate Native Americans to be civilized people. Wilder wrote, "Wondrous tales of red savages brought to Christ by the dauntless efforts of religious perfectionists found an eager audience in England, where metropolitan readers anticipated blood from such extraordinary encounters. The Puritans began the work of evangelizing Indians only after they achieved military supremacy." It was

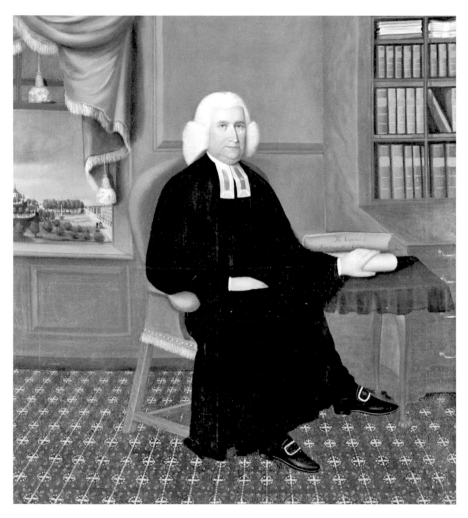

The Reverend Eleazar Wheelock, first president of Dartmouth College (1769–79). This portrait by Joseph Steward is in the Hood Museum of Art collection, Dartmouth College, Hanover, New Hampshire. *Commissioned by the Trustees of Dartmouth College.*

ironic that Wheelock believed the Native Americans should be educated, but on the contrary, the slaves he owned didn't need to be. He didn't view the African Americans in the same way that he did the Native Americans.

Originally, Wheelock's vision was Moor's Charity School in Lebanon, Connecticut, and he wanted to educate young Native American men and prepare them for missionary work. He wasn't able to get the charter for the land there, so he relocated to Hanover, New Hampshire. There was a larger population of Native Americans in New Hampshire, and he received donations

from a British earl and the land grant from Royal Governor John Wentworth to start his "Indian School."

President James Manning of the College of Rhode Island (which would later be known as Brown University) was critical of Wheelock's objective: "From what I can gather it is to be a grand Presbyterian College, instead of School for the poor Indians…Dr. Wheelock's Indian College…has already almost lost sight of its original Design." This criticism was evidenced in the fact that Dartmouth graduated fewer than twenty Native Americans in its first

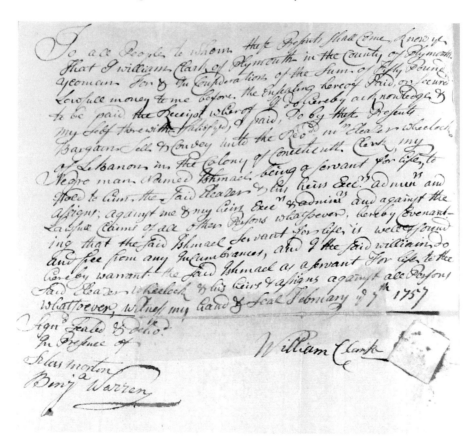

In the Rauner collection is one of the bills of sale of the Reverend Eleazar Wheelock's purchase of Ishmael from William Clark. Document excerpts follow: "To all People to whom these Presents shall come, Know ye that I William Clark of Plymouth in the County of Plymouth Yeoman for the Consideration of the Sum of Fifty Pounds Lawfull money to me before the Ensealing hereof Paid on Secured to be paid the Receipt wherof I do hereby aknowledge my Self there with Satisfyed, I paid do by these Presents Bargain Tell & Convey unto the Rev.^{dd} Eleazer Wheelock of Lebanon in the Colony of Conecticutt. Clark, my Negro man named Ishmael being a Servant for life to…Witness my hand & Seal February 17th 1757 William Clark." *Courtesy of Dartmouth College Library.*

two hundred years. There were few Native American students, and it became obvious that Wheelock's mission had changed to being a successful college for American citizens, not Native Americans. Soon, the parents sending their children to Dartmouth refused to have them cohabit with Native Americans.

Despite the mission alteration, Wheelock relied heavily on slave labor to make his college campus expand and run efficiently. Slaves cleared the lands, constructed the buildings and maintained the grounds. Wilder wrote that "there were more slaves than faculty, administration, or active trustees; in fact, there were arguably as many enslaved black people at Dartmouth as there were students in the college course, and Wheelock's slaves outnumbered his Native American students."

Throughout the early decades of Dartmouth and Wheelock's leadership, the regular routine of maintaining a college was on the shoulders of the slaves. Wilder wrote:

> In the mornings, the professors and scholars needed wood for fires, water for washing, and breakfast after morning prayers in the chapel. As students ate, their rooms were cleaned, chamber pots emptied and beds made. Multiple meals had to be produced every day in the kitchen. Ashes needed to be cleared from fireplaces and stoves, and floors needed sweeping. Clothes and shoes were cleaned and mended. Fires were lighted and maintained. Buildings wanted for repairs and servants were impressed into small and large scale projects. There were countless errands for governors, professors and students.

Wheelock built a sawmill and gristmill to supply the campus and generate income. The college had eighty acres of land, thirty-eight of which were planted with grain and corn. It also included two barns, cows and oxen and a regular supply of hay.

Not only did slavery keep Dartmouth running, but Wheelock also bought and sold slaves to help fund the college. Wilder stated that Wheelock's slave business "subsidized Wheelock's mission."

Documentation of Wheelock's Slave Sales and Purchases

In Dartmouth College's Rauner Special Collections are numerous historic documents belonging to Eleazar Wheelock, including his will, bills of sale

for slaves and correspondence about slaves he was selling or planning to purchase. Following is a sampling of the Wheelock documents.

1757: Wheelock paid William Clark of Plymouth fifty pounds for a "Negro man named Ishmael, being a servant for life."

1760: Wheelock bought Sipply (or Scipio) from Timothy Kimball in Coventry.

1760: Wheelock paid Peter Spencer of East Haddam sixty-five pounds for his "Negro man servant named Brister aged about twenty one years."

1762: Ann Morrison received seventy-five pounds from Wheelock for "a negro man named Exeter of the age of forty ought years, a negro woman named Chloe of the age of thirty five years, and a negro male child named Hercules of the age of about three years, all slaves for life."

1772: Wheelock wrote a letter to Gideon Buckingham about the transfer of ownership in regard to a slave named Nando and his wife, Hagar, to erase a debt Wheelock owed. Wheelock wrote, "I believe the situation here would be very agreeable to Nando as it is to my negroes who have agreeable company enough and live well. I have a great variety of business I can employ Nando in."

In the Rauner collection are also letters from Wheelock that regard complaints about slaves he purchased, letters he received about borrowing Wheelock slaves and other correspondence about paying for slaves or the intent to purchase slaves.

Wheeler died in 1779 and left Dartmouth in the hands of his son John. Under President John Wheelock's administration, the number of slaves in Hanover doubled. Dartmouth was still running on the backs of the slaves until slavery slowly ended in New Hampshire and New England. By the 1840s, when the abolitionist movement was in full swing, Dartmouth College had gotten the reputation of being an antislavery institution, and abolitionists were able to freely express themselves on campus. How things had changed.

In 2014, Dartmouth College students and faculty established the Dartmouth Slavery Project, which highlights the history of slavery in New Hampshire and at the college. The Dartmouth Slavery Project was the brainchild of Dartmouth sociology professor Deborah K. King to educate, research and promote the revelations that New Hampshire and, more specifically, Dartmouth College were directly connected to the transatlantic slave trade. The Dartmouth Slavery Project website cites the focus of correcting the "collective memory that not only disavowed the presence of enslaved persons in New England but cloaked its complicity with and profits from the Transatlantic Slave Trade."

Chapter 4
PORTSMOUTH SLAVE POPULATION

Portsmouth was settled in 1630 by the English, who found a prime piece of land on the coast of New Hampshire bordered by the Piscataqua River and access to the Atlantic Ocean. Strawbery Banke was the original settlement, and the city grew from there, with shipbuilding, lumber and fishing the main industries of Portsmouth. The first African American on record to set foot in Portsmouth was a man who was brought here by a Massachusetts slave trader and sold to Mr. Williams of Piscataqua in 1645.

By the 1700s, Portsmouth merchants were involved with West Indies trading, and ships were setting sail from its wharves to the African coast. One of the imports was slaves. Local slave buyers preferred slave children because they were easier to train and deal with than adults. Many of the slaves about whom there is information were brought to Portsmouth as children. The twenty Portsmouth slaves who wrote the 1779 slaves' petition were all kidnapped as children.

When the ships arrived, the slaves were sold in a number of ways. Slave auctions were held in town; taverns like William Pitt Tavern and Stoodley's Tavern held slave sales where people could view and buy. Private sales were also common, and the local newspaper, the *New Hampshire Gazette*, served as an information base for these sales. The private sales were more prevalent in the 1770s. The *Gazette* regularly ran advertisements about the sale of slaves. Many were new arrivals. Portsmouth historian Valerie Cunningham found forty-four ads in the *Gazette* during an eighteen-year period, including these:

Stoodley's Tavern, now one of the historic buildings at Strawbery Banke, was a location where slaves imported to Portsmouth were sold. *Courtesy of Michelle Arnosky Sherburne, Strawbery Banke property, Portsmouth Black Heritage Trail site.*

Dec. 22, 1758. A negro woman, 22 years old, capable of doing any sort of housework. To be sold, Enquire of Major Task at Newmarket or the Printer.

To be sold a likely negro fellow about 18 years of age, who has been in the country about 5 years. Inquire of the Printer. Feb. 21, 1759.

Imported by Robert Traill & sold cheap broad clothes—Jerseys…Also a negro girl 14 years old—been here 20 months and can speak English. —November 16, 1759

Richard Evans, Next door to the Printing Office, Market Street, Portsmouth, Keeps constantly a large assortment of Negroes, European and India Goods. On the lowest terms for cash. Portsmouth, 1797

The William Pitt Tavern was originally known as the Earl of Halifax Tavern and was owned by James Stavers. Slave sales and auctions were held here. This building was restored and is one of the historic sites at Strawbery Banke. *Courtesy of Michelle Arnosky Sherburne, Strawbery Banke property, Portsmouth Black Heritage Trail site.*

John Stavers advertised a slave sale at his tavern, Earl of Halifax (later known as William Pitt Tavern):

> *To be sold at the House of John Stavers, Inn-holder in Portsmouth next Wednesday at 3 o'clock. A few negroes lately imported in snow* [a ship]

General Townsend, Monsieur Bunbury Commander from the West Indies. Oct. 10 1760

Likely Negro Boys and Girls just imported from Gambia, and to be sold on board the Sloop Carolina *lying at the Long Wharff in Portsmouth. Enquire of Mr. Traill or of Mr. Harrison on board ship Sloop.*

James Stoodley held regular slave sales at his tavern:

To be sold at public vendue at the house of Mr. James Stoodley, Innholder in Portsmouth on Wednesday the seventh day of July at six of the clock afternoon, three Negro Men and A Boy. The conditions of the sale will be cash or good merchantable items.

Another ad for Stoodley's sales:

To be sold at public vendue at the house of captain James Stoodley, Innholder in Portsmouth on Friday next at 2 o'clock Afternoon One Negro Man, has been with the English 2 years, Negro Girl about 17…a few hogshead of West India rum…few bags of cotton wool.

Black Portsmouth: Three Centuries of African-American Heritage by Mark Sammons and Valerie Cunningham is the comprehensive work on Portsmouth's black heritage and slave lives. In these pages, there is limited space to highlight slaves in Portsmouth. The descriptions of slaves on record that follow are in conjunction with buildings that are on the Portsmouth Black Heritage Trail.

Frank and Flora at Stoodley's

James Stoodley's Tavern, built in 1761, was a gathering place of Revolutionary Patriots and a destination of Paul Revere's visit in 1774. It was also a site of auctions of bulk goods and sometimes slaves. Stoodley owned two slaves, Frank and Flora. He also owned an expensive pew in North Church plus additional seating for Frank and Flora in the upper gallery. Sometime after the Revolution, Flora appears to have attained her freedom. She married Cyrus Bruce, a freed black who was employed by Governor John Langdon.

The North Church on Market Square in Portsmouth had designated "Negro" pews that slave owners purchased for their slaves to sit in during church services. *Courtesy of Michelle Arnosky Sherburne, Portsmouth Black Heritage Trail site.*

Two Sherburne Slaves

The Sherburnes were original settlers of Portsmouth, and the Sherburne house at Strawbery Banke was built by a Sherburne circa 1695. The slave owner was Joseph Sherburne, who was a mariner, merchant and farmer. The two slaves he owned were recorded not by names but as part of the 1744 estate inventory: "one Negro man 200 [pounds], one ditto woman 50 [pounds]."

James, Fortune and Others at William Pitt Tavern

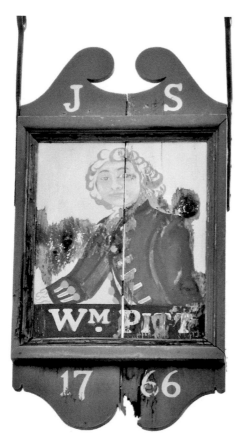

John Stavers's three-story tavern, built in 1766, was known as the Earl of Halifax Tavern, and slave auctions and sales were commonplace. It was known as a hangout for Revolutionary Patriots. Later, Stavers changed the name to William Pitt and owned slaves himself. A slave named James is remembered for the 1777 attack on a white man vandalizing the tavern. But because he was protecting his master's property, James was not punished for assaulting the man. Another slave, Fortune, ran away at sixteen years old.

Signage at the William Pitt Tavern hangs from the historic building now on Strawbery Banke's property. The building was refurbished, and the interior looks like a nineteenth-century tavern. *Courtesy of Michelle Arnosky Sherburne, Strawbery Banke property and Portsmouth Black Heritage Trail site.*

Primus, Two Female Slaves and the New Hampshire Gazette Printing Office

Primus was a well-known slave owned by printer Daniel Fowle, who published the *New Hampshire Gazette*. Fowle lived in the same building with his wife, Primus and two slave women. Primus operated the printing press for fifty years.

Prince, Nero, Quamino, Cato, Peter, John Jack and Other Slaves at the Warner House

The Warner house was built in 1716 and had such prominent homeowners as its original builder, Archibald Macphaedris; Governor Benning Wentworth; and merchant Jonathan Warner. All were slave owners. Macphaedris owned a slave girl and three men, Prince, Nero and Quamino. Warner had slaves; two were Cato and Peter, who were signers of the 1779 petition. A third, John Jack, was freed and moved to Greenland. Jack and his wife, Phyllis, harbored President Washington's runaway slave, Ona Judge Staines, in their home.

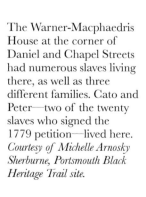

The Warner-Macphaedris House at the corner of Daniel and Chapel Streets had numerous slaves living there, as well as three different families. Cato and Peter—two of the twenty slaves who signed the 1779 petition—lived here. *Courtesy of Michelle Arnosky Sherburne, Portsmouth Black Heritage Trail site.*

Prince, Cuffee and Numerous Slaves at the Moffatt-Ladd House

Prince, who was one of the twenty African-born Portsmouth slaves who submitted a petition for abolition in 1779, was owned by William Whipple. Prince accompanied Whipple in service during the American Revolution.

Once freed from slavery, the Whipple family built this home on property given to them by their former owners. Prince and Dinah Whipple raised their family here and shared the home with Cuffee, Rebecca and their family. *Courtesy of Michelle Arnosky Sherburne, Portsmouth Black Heritage Trail site.*

Whipple agreed to grant Prince his freedom after the war. It wasn't until 1784 that Prince was freed by Whipple.

Before Prince was freed, he married Dinah Chase, who had been emancipated by a New Castle minister. Upon Prince's freedom, General Whipple's widow gave them property behind her garden on which they built a home. Prince worked as the chief steward at assemblies, balls and weddings.

Prince's relative Cuffee was owned by General Whipple but given to his brother Joseph Whipple, the customs agent in Portsmouth. Cuffee married Rebecca, and they ended up living in Prince's home too, so they must have been emancipated as well. In 1796, Prince died, leaving Dinah and several children living in the house they shared with Cuffee and Rebecca. Dinah operated a school in her home from around 1807 until at least 1835. In 1832, the white Whipples' successors moved Dinah to a property on Pleasant Street, where she lived out her life in near poverty.

Cyrus Bruce and Flora Stoodley at the Langdon House

In an unusual situation, Cyrus Bruce was a slave of Senator John Langdon (who later would become governor), who chose to free his slaves and then hire them as employees. Cyrus was emancipated in 1783 and served as Langdon's valet and butler. In 1797, he was given housing as compensation. Cyrus and his wife, Flora Stoodley, lived behind the mansion in one of two houses Governor Langdon owned on Washington Street.

Other slaves who lived in Portsmouth included the petitioners: Seneca Hall, Peter Warner, Cato Warner, Pharaoh Shores, Winsor Moffatt, Garrett Colton,

The Sherburne House, at Strawbery Banke, built in 1695, housed the Joseph Sherburne family in the 1700s. He owned two slaves who were listed in the 1744 estate inventory only as "Negro man and woman." *Courtesy of Michelle Arnosky Sherburne, Strawbery Banke property and Portsmouth Black Heritage Trail site.*

Kittindge Tuckerman, Peter Frost, Prince Whipple, Nero Brewster, Pharaoh Rogers, Romeo Rindge, Cato Newmarch, Cesar Gerrish, Zebulon Gardner, Quam Sherburne, Samuel Wentworth, Will Clarkson, Jack Odiorne and Cipio Hubbard. Other slaves whose names and stories survived are Pomp and Candace Spring; Dinah Gibson; Nanney Langdon; Violet Dearborn; Newport Stiles; Nan Appleton; Tony Hunking and his children, Caesar, James and Samson; Joseph and Nancy Cotton and their children, Eleazor and James; and Adam, Mercer and Bess Marshall.

There were hundreds more—though nameless after two hundred years—remembered.

Chapter 5
THE 1779 SLAVES' PETITION

Three years after the thirteen colonies declared their independence and became the United States of America, slaves in Portsmouth decided that it was time for freedom for slaves as well. Slaves had sacrificed their lives and fought in the American Revolution for this new country. They felt they deserved freedom as much as white people. When copies of the Declaration of Independence arrived in Portsmouth, the city was excited to hear it read in public. Slaves heard the words and understood what it meant. They wanted the same for themselves.

Portsmouth's own William Whipple, who had served as a general in the Revolution, became a part of history on July 4, 1776, when he signed his name on the most important of all American documents: the Declaration of Independence. General Whipple's slave Prince Whipple knew his owner was famous. Word was all over the city about Whipple being a part of that moment in history. It may have been that in those three years after our country's formation, Prince and his friends were working on a chance at their own freedom.

Historians and authors Mark Sammons and Valerie Cunningham agreed that the slaves wrote the 1779 petition themselves. It was not contrived by a white abolitionist who wrote the document and had the slaves sign it. Portsmouth slaves knew how to read and write, and they knew the power of the written word.

The petition epitomized the desire of slaves for real freedom. Being slaves in New England wasn't any different than in the southern states.

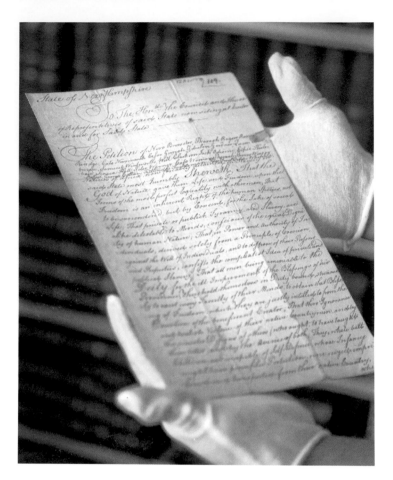

The 1779 slaves' petition was found in the New Hampshire State Archives in the twenty-first century. The petition was written and signed by twenty slaves from Portsmouth who requested abolition of slavery from the New Hampshire legislature. State archivist Brian Burford holds the petition for the photographer. *Courtesy of* Concord Monitor, *Alexander Cohn, photographer, photo published January 6, 2013.*

They were not allowed to be their own people. They were not respected, had no rights and were treated no better than cows in the barn or horses in the stall. The ignorant mentality of white slave owners was that slaves didn't know any different and didn't want freedom. They believed they didn't have the capacity to know what freedom was and needed to be herded and ordered around.

The Portsmouth petition is the symbol of their convictions that they, too, deserved rights and equality. As early as the 1770s, slaves were thinking of

that freedom. Their generation had seen the colonists fight for their rights to be free from the British king. They heard the rhetoric and proclamations to fight for their rights. And the slaves took that as their example. "Now it is our turn," the petitioners were stating. As the country developed and matured, so should the laws.

The petition read:

State of New Hampshire
To the Hon^ble the Council and House of Representatives of said State now siting at Exeter in and for Said State—
The Petition of Nero Brewster, Pharaoh Rogers, Romeo Rindge, Cato Newmarch, Cesar Gerrish, Zebulon Gardner, Quam Sherburne, Samuel Wentworth, Will Clarkson, Jack Odiorne, Cipio Hubbard, Seneca Hall, Peter Warner, Cato Warner, Pharaoh Shores, Winsor Moffatt, Garrott Colton, Kittindge Tuckerman, Peter Frost & Prince Whipple, Natives of Africa, now forcibly detained in Slavery in said State most humbly Sheweth, That the God of Nature, gave them, Life, and Freedom, upon the Terms of the most perfect Equality with other men; That Freedom is an inherent Right of the human Species, not to be surrendered, but by Consent, for the Sake of social Life; That private or publick Tyranny and Slavery, are alike detestable to Minds, conscious of the equal Dignity of human Nature; That, in Power and Authority of Individuals, derived solely from a Principle of Coercion, against the Will of Individuals, and to dispose of their Persons and Properties, consists the compleatest Idea of private and political Slavery; That all men being ameniable to the Deity for the ill Improvement of the Blessings of his Providence, They hold themselves in Duty bound, strenuously to exert every Faculty of their Minds, to obtain that Blessing of Freedom, which they are justly intitled to from the Donation of the beneficient Creator; That thro' Ignorance and brutish Violance of their native Countrymen, and by the sinister Designs of others (who ought, to have taught them better) and by the Averice of both; They while but Children, and incapable of Self-Defence, whose infancy might have prompted Protection, were seized Imprisoned and transported from their native Country, where (Tho' Ignorance and In christianity prevail'd) They were born free, to a Country, where (tho' Knowledge, Christianity and Freedom, are their Boast) They are compelled & thier unhappy Posterity to drag on their Lives in miserable Servitude!—Thus, often is the Parent's Cheek wet for the Loss of a Child, torn by the cruel hand of Violence from her aking Boosom! Thus, often, and in vain, is the Infant's Sign for the

nurturing Care of its bereaved Parent! and thus, do the Ties of Nature and Blood, become Victims, to cherish the Vanity and Luxury of a Fellow Mortal! Can this be Right?—Forbid it gracious Heaven!—

Permit again your humble Slaves to lay before this Honarable Assembly some of those Greivances which They dayly experience and feel; Tho' Fortune hath dealth out our Portions with ruged hand, Yet hath She smiled in the Disposal of our Peresons to those, who claim us, as thier Property; of them, as Masters, we do not complain: But from what Authority, they assume the Power to dispose of our Lives, Freedom and Property, we would wish to know; Is it from the sacred Volumes of Christianity? Where we believe it is not to be found! but here hath the cruel hand of Slavery made us incompetent Judges, hence Knowledge is hid from our Minds! Is it from the Voumes of the Laws? of these also, Slaves can not be Judges, but those, we are told are founded in Reason and Justice; it can not be found there! Is it from the Volumes of Nature? No! Here we can read with others! Of this Knowledge of Slavery can not wholly deprive us; Here we know that we ought to be free Agents; Here, we feel the Dignity of Humman Nature! Here, we feel the Passions and Desires of men, tho' check'd by the Rod of Slavery! Here, we feel a Just Equality! Here, we know that the God of Nature made us free! Is thier Authority assumed from Custom? if so, Let that Custom be abolilshed, which is not founded in Nature, Reason nor Religion; Should the Humanity and Benevolence of this Honorable Assembly restore us to that State of Liberty of which we have been so deprived, We conceive that those, who are our present Masters, will not be Sufferers by our Liberation, as we have most of us spent our whole Strength, and the Prime of our Lives in their Service; And as Freedom inspires a noble Confidence and gives the Mind an Emulation to vie in the noblest Efforts of Interprize, and as Justice and Humanity are the Result of your Deliberations; we fondly Hope that the Eye of Pitty and the Heart of Justice may Commiserate our Situation and put us upon the Equality of Freemen and give us an Opportunity of evincing to the World our Love of Freedom, by exerting ourselves in her Cause, in opposing the Efforts of Tyranny and Oppression over the Country in which we ourselves have been so long injuriously inslaved—

Therefore your humble Slaves most devoutly Pray, for the Sake of injured Liberty, for the Sake of Justice, Humanity, and the Rights of Mankind; for the Honour of Religion, and by all that is dear, that your Honours would graciously interpose in our Behalf, and enact such Laws and Regulations, as you in your Wisdom think proper, whereby we may regain our Liberty &

Be rank'd in the Class of free Agents, and that the Name of Slave may not more be heard in a Land gloriously contending for the Sweets of Freedom; And your humble Slaves as in Duty bound will ever Pray Portsmouth November 12ᵗʰ 1779

/s/ Seneca Hall, Peter Warner, Cato Warner, Pharaoh Shores, Winsor Moffatt, Garrett Colton, Kittindge Tuckerman, Peter Frost, Prince Whipple, Nero Brewster, Pharaoh Rogers, Romeo Rindge, Cato Newmarch, Cesar Gerrish, Zebulon Gardner, Quam Sherburne, Samuel Wentworth, Will Clarkson, Jack Odiorne, Cipio Hubbard.

The verbiage these men used declared their belief that God was the creator of equality and that men shouldn't have taken it away. The points they focused on were intellectual and impressive arguments. They pointed out the injustice of being stolen from their homeland while only children and existing in a foreign country against their wills.

The wordsmithing was eloquent and intelligent. These men crafted an official document that exemplified the desires of all slaves. It is a shame that it was not taken seriously. Imagine the courage it took to steal away and meet to discuss the creation of the petition. That same courage had to be used to take it to the next level: presenting it to the state's governing body. It could not have been easy for the slaves to get away from their owners and their duties; travel to the statehouse, which was in Exeter at the time but still a trip from Portsmouth; stand together and present the petition to mocking, condescending whites; face ridicule as they got through the event; and then wait to see if they would face retribution from their masters or the law or if anything would come of it.

The New Hampshire legislature received the petition and on April 25, 1780, voted that the petitioners would be granted an audience at the next session and that the petition had to be published in the *New Hampshire Gazette* for three weeks.

Interestingly, the first legislative action was signed by Senator John Langdon of Portsmouth. He had been an unwilling party in the attempt to capture President George Washington's runaway slave, Ona Judge Staines.

The legislature revisited the petition issue on June 9, 1780, and it was discussed in the assembly's proceedings. No decision was reached, and the next motion was "that at this time the House is not ripe for a Determination in this matter: Therefore ordered that the further consideration & determination of the matter be postponed till a more convenient opportunity." The subject was never brought up again in legislative session. The petition ended up in the files.

Sammons and Cunningham wrote, "Though the legislature never entertained arguments on behalf of the petition, the petition's message was ultimately comprehended by some of the petitioners' owners."

Ten years later, six petitioners were given their freedom: Peter Warner, Pharaoh Shores, Jock Odiorne, Prince Whipple, Cesar Gerrish and Romeo Rindge. Though only six people, it was still a result of the courage it took to stand up for their beliefs.

Slavery was legal in the state until eighty-five years after the slaves' petition. In 1857, a law was passed that didn't say it "abolished slavery" or that it was illegal to own someone, but it did grant full citizenship to any person regardless of their race.

More than two hundred years later, the slaves' petition surfaced in the state archives. The importance of the document was known immediately, but it took almost thirty years to get it to the forefront of the state legislature once again. Historians worked to get recognition for the twenty men who spearheaded this attempt at abolishing slavery in New Hampshire in 1779. In 2013, New Hampshire governor Maggie Hassan posthumously freed the fourteen slaves who had signed the original petition but were not given their freedom. This twenty-first-century emancipation commemorated those brave men.

Part II

BEING BLACK IN NEW HAMPSHIRE: CONTRASTING EXPERIENCES

AMOS FORTUNE—JAFFREY

Double standards existed for blacks during the antebellum period. It was a confusing atmosphere in this country with so many social levels for blacks. Slaves were not considered people; freed blacks were tolerated but not treated as equals; fugitive slaves were never really safe as long as they were in the United States under a government that allowed slavery. A black free person could live in one town in New England and be accepted and not face major persecution or prejudice, but the neighboring community might not tolerate blacks and might force segregation.

The story of Amos Fortune must start at the end to appreciate the impact that he had on the New Hampshire town he chose as home. On his headstone is the inscription: "Sacred to the memory of Amos Fortune, Who was born free in Africa, a Slave in America. He purchased his liberty, Professed Christianity. Lived Reputably, Died Hopefully Nov. 17, 1801, a. 91."

Fortune's history was not erased from the town's memories as so many other former slaves had been in the state. His life was exemplary. He was determined to be successful and live free and was fortunate to do so.

Fortune was born on the west coast of Africa around 1710. Not much is known of his life there, but he was kidnapped and brought to New England and sold into slavery. It is not clear who Amos's first owner was, but records show that by the 1760s, he was owned by Ichabod Richardson of Woburn, Massachusetts. Richardson was a Quaker who

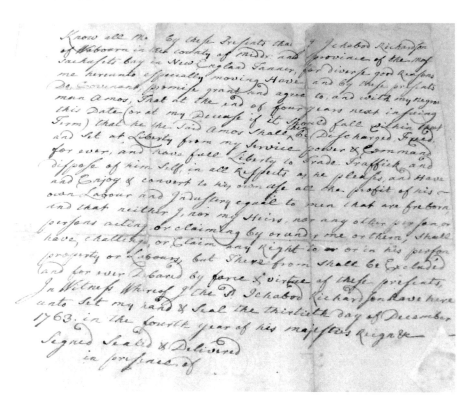

Amos Fortune's owner, Ichabod Richardson, originally drafted Fortune's manumission document in 1763, but it was never signed. The document is in the Amos Fortune Collection and states: "Know all men by these Presents that I Ichabod Richardson of Woburn in the county of Middx: and province of Massachusets-bay in New England Tanner, for diverse good Reasons me hereunto especially moving Have and by these presents do Covenant, promise grant and agree to, and with my Negroe man Amos, That at the end of four years next insuing th..s Date (or at my Decease if it should fall within that Term) that he the said Amos shall then be Discharged, Freed, and Set at Liberty from my Service power & Command for ever, and have full Liberty to trade Traffick and dispose of him Self, in all Respects as he pleases, and Have and Enjoy & convert to his own use all the profit of his own Labour and Industery equal to men that are freborn, and that neither I, nor my Heirs, nor any other person, or persons acting, or claiming by or under me or them, Shall have, challenge, or Claim any Right to, or in his person property or Labours, but Therefrom shall be Excluded and for ever Declared by force & virtue of these presents, In Witness Whereof I the Sd Ichabod Richardon have here unto Set my hand & Seal the thirtieth day of December 1763 in the fourth year of his majesties Reign &c Signed Sealed & Delivered in presence of." *Courtesy of the Amos Fortune Collection in possession of the Jaffrey Public Library.*

trained Fortune in the tanning trade. Richardson allowed Fortune to set aside money and draft a manumission document in 1763, but it was unsigned, so it was not legal.

At first glance, Richardson appears to have been helping Fortune, and the missing signature may have been an oversight. But a note on the back of the document may hold the true meaning to a different motive. It reads, "To Old to do any good or hurt." Slave owners were infamous for granting manumission to old slaves who were becoming unproductive. Fortune would have been about fifty-three at that time.

Richardson died in 1768, and Fortune's freedom was put on hold as the estate was settled and property, including Fortune, was sold to a Richardson heir, Simon Carter. It was Carter who allowed Fortune to pay for his freedom over several years. Finally, Fortune finished making payments and was freed on November 23, 1770.

He was ready to start a new free life. He bought a half acre and a house in Woburn in 1774. Four years later, Fortune wanted to marry slave Lydia Somerset. He bought her for fifty pounds from Isaac Johnson so she could be free.

> *Bilreca, June ye 23 1778*
> *Then Recd of Amos Fortune fifty pounds in full for a Negro gade Names*
> *Lydia Sumersete being now my property the which I do Sell and Convay*
> *to the aforesaid Amos and I do Covenant with the Said Amos that I have*
> *juste and Lawfull Rite to Sell and Convay the Said Lydea in the manner*
> *afoursaid and I will warrante and Defend the Sais Lydia to him againste*
> *all the Lawfull Clames and Demands of all persons What Ever.*

They married about July 8, 1778, but sadly, Lydia died three months later.

A year later, Fortune wanted to marry Violat, a slave of James Baldwin in Woburn. He purchased her on November 9, 1799, and married her on November 10. The following is Violat's bill of sale:

> *This Day Received of Amos Fortune Fifty pounds in full for a Negro*
> *Woman Named Vilot being now my property which I now do Sell and*
> *Convey to the afore said Amos and I do Covenaant with the Said Amos*
> *that I have a just and Lawfull Right to Sell and Convey the said Vilot in*
> *manner as afore said and I will Warrant and defend the said Vilot to him*
> *the said Amos against the Law full Claims and Demands of all Persons*
> *What ever. Dated Woburn 9th November 1779.*

Violat would be his soul mate in their journey of freedom together. In the inscription on her gravestone, she is remembered as Amos's wife, friend and solace.

The Fortunes decided to move north when Amos was seventy years old in 1781. They chose Jaffrey in southern New Hampshire. Upon their arrival, the town constable met them to warn them out of town. This "warning out" was a common practice in the eighteenth century. Any newcomers, no matter their race, were officially warned that the town would not allow them to stay if they were going to be burdens on the community and expect financial support. At first glance, it seemed as if the Fortunes' warning out was racially based, but it wasn't.

It didn't take long for Amos to open his tanning business. His skill and talent as a tanner was quickly realized by area people, and his business grew.

In 1785, Amos and Violat invited her adopted daughter, Celyndia, from Woburn to live with them. They didn't have children but raised her. By 1789, Amos was able to buy twenty-five acres near Tyler's Brook on which he built a home for them and a tannery. His reputation in business spread, and he had customers from all over southern New Hampshire and eastern Massachusetts. He added apprentices to his business to help with the

The Amos Fortune house is on Amos Fortune Road in Jaffrey, New Hampshire. It is privately owned, but the Amos Fortune collection is housed at the Jaffrey Public Library. *Courtesy of Libby Fell.*

workload and teach the trade. All this time, Amos was in his mid-seventies, working as if he were twenty.

The Fortunes were involved with the Jaffrey church and became members. Amos was a free man with the rights of any citizen in Jaffrey. He became a charter member of Jaffrey Social Library, a prominent circle of Jaffrey citizens who met regularly for book discussions and shared books. When the library group had a need for a place for exchanging books, Fortune and the minister, Reverend Laban Ainsworth, worked together to initiate the project. Fortune also donated his bookbinding skills for the library.

Many of Fortune's business transactions were preserved, and from the receipts, sales agreements, loan papers and other documents that remain in the Fortune collection, we get a glimpse of late eighteenth-century business in New England.

Amos and Violat lived the freed slaves' dreams on American soil. They were accepted into the community, owned their own land and lived their lives happily and without persecution.

Amos died in 1801 at the age of ninety-one, and Violat died a year later. Amos was the first benefactor in Jaffrey, leaving bequests in his will to the school and church. The church bought a pewter communion service in his honor. When the school closed, the money he had left it sat unused for a long time. Eventually, the accrued fund was put into a trust for the Jaffrey Public Library's children's department.

Amos was honored as "an exemplary citizen of colonial New England" by the New Hampshire Historical Markers Program. The road to Sharon where his house still stands is named Amos Fortune Road.

In 1946, Jaffrey residents started the Amos Fortune Forum summer lecture series in the Jaffrey Meeting House. It brought distinguished speakers such as Thornton Wilder, Edwin Land and Harlowe Shapley. In 2000, the forum commissioned the *Amos Fortune* publication by Peter Lambert.

In 1950, Elizabeth Yates brought Amos to the nation's attention when she published *Amos Fortune, Free Man*. The book won the 1951 Newbery Medal, the American Library Association award for the most distinguished contribution to American literature for children. Soon after, the State of New Hampshire proclaimed February 20, 1955, as Amos Fortune Day. Alexander F. Magoun published a detailed history called *Amos Fortune's Choice* in 1964.

Violat Fortune came into the spotlight when a miniature painting credited from the American School era of 1785–1802 surfaced at the Christie's auction house in New York City in the 1990s. The portrait—of an attractive young mulatto woman in a handcrafted wood frame that is labeled "Jaffrey,

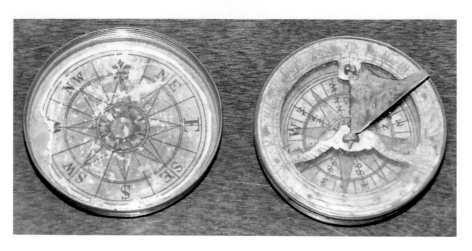

The first benefactor in Jaffrey was Amos Fortune, a former slave who moved to New Hampshire a free man. This is Fortune's compass that is in the Amos Fortune Collection housed at the Jaffrey Public Library. *Courtesy of Michelle Arnosky Sherburne and Amos Fortune Collection.*

N.H."—was in a collection of early American art. Christie's contacted the New Hampshire Historical Society and Jaffrey Historical Society about the acquisition, and it was thought that it was a portrait of Violat. It was sold in a private sale for $1,600.

Woburn, Massachusetts, where Amos lived as a slave and bought his freedom, honored him and dedicated Amos Fortune Square in 1989.

The Amos Fortune documents, including the manumission papers and other important documents, were in the possession of one of the original Jaffrey families. They eventually were donated to the Town of Jaffrey and kept in the Jaffrey Public Library's care.

RICHARD POTTER—ANDOVER

A New Hampshire historic marker on Route 11 near Potter Place Village in Andover is a tribute to the man who was the first African American magician in the country and whose namesake the area honors: Richard Potter. The sign states, "The community takes its name from Richard Potter, noted magician, ventriloquist and showman. This 19th century master of the Black Arts was known throughout America. He died here in 1835 in his mansion, a showplace in the town. He is buried in a small plot on his once extensive estate."

Potter was born in 1783 in Hopkinton, Massachusetts, the son of Sir Charles Henry Frankland and his African servant, Dinah. He received a good education and, due to his father's wealth, was able to travel around Europe as a young man. It is unclear where he started learning the art of magic.

It was recorded that he worked as a servant for the family of General Henry K. Oliver and that is where he first showed his magic in front of the family. He met John Rannie, a famous British magician and ventriloquist, and began touring with him. Around 1800, Rannie and Potter came to the United States and traveled with a circus. Potter served as Rannie's assistant. In 1808, he married Sally Harris and moved to Andover, New Hampshire. They bought a 175-acre farm that they called Potter Place and raised a family there. He joined the Boston lodge of Masons and was a successful member.

Potter started his solo career at a local tavern and then began touring. In 1811, he began his performances at the Columbian Museum in Boston. He was known as a ventriloquist and had numerous tricks. He was a born showman and played on the fact that he was mystical and even thought to be Hindu and not a mulatto.

In a 1916 magazine, Henry Hatton wrote that the first magician he ever saw appeared at the old Olympic Theater in New York. Hatton wrote, "Little Potter he was called. He was a young colored man, slim and graceful, and he danced and sung. One verse of his song ran: 'They call me a mulatto, And my name is Little Potter, and for cutting up the capers, I'm the dandy O!'"

Potter's career was highlighted in a 1906 issue of Harry Houdini's *Conjurers' Monthly Magazine* in an article written by G. Dana Taylor, who wrote:

> *I can give you some account of a certain man named Richard Potter, who was known as a wonderful magician. He was born in 1783 and lived 52 years. He was part Hindoo and was married. Potter was a hypnotist and a celebrated ventriloquist. Here are a few wonders he performed. Before a score of people and in the open air, free from trees, houses or mechanisms, he threw up a ball of yarn and he and his wife climbed up on it and vanished in the air.*

During the next twenty-two years, Potter toured New England and New York. He appeared regularly in Boston as "Mr. Potter." His repertoire of tricks grew every year. It is said that Potter taught the famous Harry Houdini some of his specialty magic tricks.

Most of Potter's touring was in New England, but he did venture to the southern states. He experienced extreme prejudice on a twenty-day tour in Alabama. In the North, he didn't seem to encounter high degrees of prejudice because of his entertainment value.

Potter died in 1835.

Chapter 8
HARRIET WILSON—MILFORD

Barbara White wrote in *Harriet Wilson's New England* about a woman who was the author of an 1859 novel: "The heroine is a Northern servant, not a Southern slave; at the tender age of six Frado finds herself indentured to the Bellmont Family, becoming 'our nig' to Mrs. Bellmont, a 'she-devil' who overworks and beats her."

The novel was *Our Nig; or, Sketches from the Life of a Free Black, in a Two-Story White House, North. Showing that Slavery's Shadows Fall Even There*, and the author, Harriet Wilson, was a free black woman who wrote about her own life through the fictional character Frado. After a harrowing childhood as an abused servant in a white family living in New Hampshire, Frado lived as unequal to the free people around her in her home state and then Massachusetts. She found that though a free woman, life wasn't fair and she wasn't treated the same as a white free woman.

Harriet "Hattie" Adams was born in Milford, the daughter of a free African American and an Irish white woman. After her father died, she was left as an indentured servant at the home of Nehemiah Hayward Jr., a wealthy farmer in Milford. From the age of six to eighteen, she was physically, verbally and emotionally abused by Mrs. Hayward. She worked as a house servant and a farmhand and was forced to labor as if an adult. Her life was a constant battle, with only glimpses of kindness from one of the Hayward sons and an old aunt who lived with them. The abuse she faced was overlooked by the man of the house and seemingly everybody in Milford, even the staunch abolitionists.

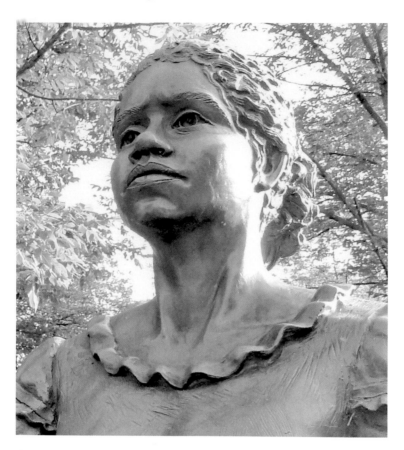

The Harriet Wilson statue shows Wilson's profile. The full statue shows Wilson holding her book with her young son George standing beside her cast in bronze. The statue is in Milford's Bicentennial Park and is part of the Milford Black Heritage Trail. *Courtesy of Michelle Arnosky Sherburne.*

When she turned eighteen, she was released from indenture and tried to survive on her own. She worked as a house servant and seamstress in households in New Hampshire and Massachusetts. She ended up in Boston. She met a self-professed fugitive slave, Thomas Wilson, who was lecturing around New England. They married in 1851, and then she learned that he was a scam artist and never had been a slave. He abandoned Wilson when she was pregnant. She ended up at the poor farm in Goffstown, New Hampshire, where her son, George Mason Wilson, was born in 1852.

A glimpse of hope occurred when Thomas returned, rescuing her and the baby from the poor farm. But he had become a sailor and left on a voyage, never to return. Wilson was forced to leave her son at the poor farm.

Historians have tried to piece together Wilson's adult life. She moved to Boston and worked as a dressmaker and as a household servant. She may have married again to a man named Robinson. She was befriended by a barber and his family, at which time she may have learned to read. Wilson was given a hair tonic formula from this family, and she marketed it for a while, but her poor health hindered her travels and sales.

It was while living in Boston that Wilson wrote *Our Nig*. On September 5, 1859, the novel was published by George C. Rand and Avery, a publishing firm in Boston. As Wilson explains in the preface, the book was an attempt to get her son back: "Deserted by kindred, disabled by failing health, I am forced to some experiment which shall aid me in maintaining myself and child without extinguishing this feeble life."

Tragically, her son George died of fever only six months after the book came out in February 1860.

Wilson attempted selling the book but only marketed it in a small area. Three years later, she was back at the poor farm in Milford. But her name surfaces again in public records in 1867. The Spiritualist Movement hit America in the late nineteenth century. Wilson became a Spiritualist and was known as "the colored medium" by the name of Mrs. Hattie E. Wilson. From 1867 to 1897, she worked as a Spiritualist healer, clairvoyant, trance reader and lecturer. She was active in the local Spiritualist community and lectured at camp meetings, theaters and around New England and as far as Chicago.

In addition, for nearly twenty years from 1879 to 1897, she was the housekeeper of a two-story boardinghouse in the South End of Boston. She rented out rooms, collected rents and provided basic maintenance.

On June 28, 1900, Wilson died in Quincy Hospital in Quincy, Massachusetts.

GEORGE BLANCHARD—MILFORD

George Blanchard had been born a slave in Andover, Massachusetts, but gained his freedom after service in the Revolutionary War. As a free man, recently married, Blanchard wanted to start a new life in New Hampshire. Like the Fortunes, the Blanchards received the warning out upon arrival in Wilton, a town only half an hour east of Jaffrey where Amos Fortune found life free. They settled there anyway, starting a family and purchasing a forty-acre farm. His first wife died, and he remarried. His family grew to include ten children.

By 1805, the Blanchard family had moved farther east to Milford, a well-known abolitionist town. He bought a farm and set up his veterinary shop. Blanchard was skilled as an animal healer and became one of the first veterinarians in New Hampshire. He was well known and traveled around southern New Hampshire and central Massachusetts treating animals. Years passed, and Dr. Blanchard passed his veterinarian business to his son Timothy and was able to retire. He focused on his farm until his death in 1824.

Timothy was known as "Dr. T. Blanchard" and kept the business going for a while. He married a white woman named Dorcas, and they had six children and lived comfortably. Tim had been buying and selling land, but the Panic of 1837 happened, and the bottom fell out on him. He ended up selling his farm and tried to recover financially. Then he died suddenly at age forty-eight. His wife and their children were at the mercy of the estate executors, and the future didn't look good. Dorcas remarried quickly and

abandoned her children. They ended up being placed in the poor house or in Massachusetts families.

The Blanchard families were no longer in Milford, and the legacies of Drs. George and T. Blanchard drifted away in the memories of Milford residents. Contributions that Dr. George Blanchard had made in pioneering veterinarian service in New Hampshire faded into obscurity. Though his son had continued the family veterinarian business, he did fail financially. Did all the work and strides that the Blanchards made deserve erasure because of financial difficulty?

Reginald Pitts wrote in *Harriet Wilson's New England*: "Soon Tim Blanchard, with the majority of his family, was forgotten by Milford…After his death his homestead became known as the 'Pete Shedd' Farm even though the Shedds themselves would not live there as long as the Blanchards, since they lost the property when they failed to pay property taxes on it."

Time wore on, and by the early 1900s, the Milford town history downplayed the time spent in town by the Blanchards. The Blanchards' contributions didn't seem worth crediting in edited Milford history. Black heritage in Milford disappeared from the records until Harriet Wilson's book surfaced in the twentieth century and shed light on it.

Chapter 10
THE TRAGEDY OF NOYES ACADEMY

E vents that occurred in Canaan in 1835 exemplify the atmosphere in the United States at that time. Noyes Academy, a biracial school established by abolitionists in New Hampshire, became the focus of hatred, prejudice, ignorance and racism by northerners who were not tolerant to having blacks treated as equals.

The story began with a group of abolitionists who set out to have a school that would provide higher education to teenagers of any race. They received a charter on July 4, 1834, from the New Hampshire legislature; there were sixty local financial contributors to buy land and build a school on property south of the Congregational church on Canaan Street.

Word spread quickly that the academy would accept free black students from all over the country. The main reason for opposition was prejudice. Area people, though not necessarily all Canaan residents, did not believe that blacks should be educated and treated equally. Before Noyes Academy even opened its doors, the opponents, led by Canaan resident Jacob Trussell, held town meetings over the course of a few months to garner support to close the school. Only a fraction of the town's population was present: eighty-six out of three hundred. Recorded in the *History of Canaan*:

> *The establishment of a school for the purpose of mingling promiscuously, for the purpose of instruction [of] the Black as well as the white children of our country, and have by their vote and declaration, declared that they will receive such blacks into said Academy for instruction and into their*

families as boarders on the same terms as the whites…and compel their own children and boarders, and all who may attend said Academy to associate with them, without regard to colour, thereby not only outraging the feelings of the inhabitants of said town, setting aside the very distinction the God of Nature has made in our species in colour, features, disposition, habits and interests, but inviting every black, who may obtain means by the aid of his own friends and by the aid of a Society heated by Religious and Political zeal, to a degree that would sever the Union for the purpose of emancipation. Therefore resolved That we view with abhorrence every attempt to introduce among us a black population, and that we will use all lawful means to counteract such introduction…

Resolved, that we view the abhorrence the attempt of the Abolitionists to establish a school in this town, for the instruction of the sable sons and daughters of Africanus, in common with our own sons and daughters and that we view with contempt every white man and woman who may have pledged themselves to receive black boarders.

Noyes Academy opened on March 1, 1835. The trustees and incorporators included Canaan abolitionists, the well-known antislavery newspaperman Nathaniel Peabody Rogers and New Hampshire state representative George Walworth. The others were Samuel Noyes, Nathaniel Currier, John Hough Harris, George Kimball, Dr. Timothy Tilton, David Child, Samuel Sewall, the Reverend William Munroe, George Kent and Samuel Cox. Munroe was the only black founding trustee and lived in Portland, Maine, at the time. He had served in 1842 as a teacher at a Detroit black school that was not well received either. He founded St. Matthew's Church in Detroit in 1846.

The school offered two courses of study and included the regular classes of reading, writing, arithmetic, bookkeeping, geometry, algebra, surveying, astronomy, navigation, geography, general history, natural history and more. Classical courses included ancient geography; Grecian, Roman, Egyptian and Jewish antiquities; and mythology.

John Hough Harris and George Kimball provided housing for the black students.

There were fifty-two students in 1835, and fourteen of them were African Americans who traveled from such far distances as New York City, Boston and Providence, Rhode Island. Some of the students became prominent figures in the abolitionist movement, including Henry Highland Garnet, Alexander Crummell, Richard Rust and Julia Williams (later she became Garnet's wife).

Students of Noyes Academy stayed in the George Kimball House in Canaan until the destruction of the school. The Kimball House was torn down in the twenty-first century, and all that remains are photographs. *Courtesy of Donna Zani-Dunkerton private collection.*

Crummell wrote about traveling to Canaan. Because of their race, the students were refused inside passage and had to stay on the upper deck of the steamboat from New York to Providence. They were not allowed in hotels or served at restaurants once they reached Providence and Boston. Initially, he felt a warm welcome when they reached Canaan. "It was the first step, in our lives into the world of freedom, brotherhood and enlightenment," he wrote.

Upon the black students' arrivals, Elijah Blaisdell, Jacob Trussell and others were indignant. They watched the progress of the school bitterly. An article in the *New Hampshire Patriot* in June 1835 reported that since the school had opened, it was common to see black men walking arm in arm with white women or tea parties with blacks invited or blacks being waited on by white servants. The article stated, "We do not wonder that the white people of Canaan should consider such an establishment a 'nuisance' and that they should adopt all lawful measures for its removal. The people of this state have more than once been reproached as favoring the pernicious schemes of the Abolitionists."

By July, Trussell and the opponents had had enough. On July 4, 1835, approximately seventy men gathered for an attack on the school. Dr. Tilton met them and issued warnings, and the crowd dispersed in defeat. Two more meetings were held on July 11 and 31, and it was decided that the removal of the school had to be done legally. *The History of Canaan* reported that a resolution was passed "to see what measures the town will take to expel the blacks from the town of Canaan."

They set the official date and time to remove the building and force the closing of Noyes Academy. The opponents also wanted to make sure that everyone in the country would hear about it, so they directed that reports of the meeting should be sent to local, state and abolitionist newspapers.

The Great Hauling, August 10, 1835

Early Monday morning, August 10, began with Canaan Street filled with seventy men from Enfield, Hanover and Dorchester carrying iron bars, chains, axes and wagons filled with equipment and about ninety-five yoked oxen headed for Noyes Academy.

Captain of the mob Trussell announced, "Gentlemen, your work is before you. This town has decreed this school a nuisance, and it must be abated. If any man obstructs you in these labors, let him be abated also. Now fall to, and remove this fence!"

The Destruction of Noyes Academy was painted by Mikel Wells in 1999. She was commissioned by the Canaan Historical Society and then donated the painting to the society. *Courtesy of painter Mikel Wells, 1999, owned by Canaan Historical Society, photo of painting by Michelle Arnosky Sherburne.*

Once again, Dr. Tilton came to the defense of the academy. He tried to stop the mob, but this time Trussell had his men remove Tilton from the premises. No one else connected to the school tried to stop the violence. They truly were outnumbered. The students feared for their lives and remained in their dorms wracked with fear.

Axes struck the walls and doors. Crowbars pried up the building, lifting and loosening it. Trussell supervised, shouting out commands. By noon, chains had been hooked around the base of the building and the teams were attached. The mob worked with the teams to pull the building off the foundation, but the chains broke.

Passersby were wary of the mob crew working. It was an ugly scene in the middle of town that day.

They worked in the afternoon heat, but the building wouldn't budge. Finally, the building shifted and the teams pulled it off the foundation. By 7:00 p.m., the mob had dragged the academy into the middle of the road.

Calling it quits for the day, the oxen were taken to a nearby field to rest for the night. That night, Trussell and his crew went to get more cables.

On Tuesday morning, August 11, the work crew assembled and continued its quest. Progress went quicker, dragging the building down the street. By noon, the men had stopped in front of the general store, demanding a barrel of rum be brought out. One of the store clerks blocked the storage doors and refused, but after much struggling, Trussell's men had rum.

It took all afternoon to drag the academy building to the corner of the common, right in front of the old church. Trussell took the opportunity to calm his mob and announce resolutions, one of which was:

> *Let there be a union of all honest men, throughout all the United States, and an undivided and uncompromising opposition be presented to irredicate [sic] Abolition wherever found.*
>
> *The Abolitionists, a combination of disorganizers led on by an Englishman sent to this country to sow seeds of discord between the North and South. May he be removed from the continent as suddenly as the Noyes Academy has this day been removed from the control of the Abolitionists.*

Trussell was referring to the famous British abolitionist George Thompson, who had been invited to New England by William Lloyd Garrison to lecture about abolishing slavery.

They were exhausted, both men and oxen, and decided to leave the building in front of the church. It was a celebration night filled with drinking,

celebrating their triumph, antagonizing townspeople and threatening to attack the boardinghouse where the students were housed.

Twelve black students were in danger. One of them, Henry Highland Garnet, later related that the mob surrounded the house where he and other students were living. A shot was fired into the room at the George Kimball house that Garnet and his friend Crummell were in. Garnet, in response, took a rifle and fired a shot to discourage the mob. He and two friends left Canaan that night. They crossed through the lower part of Vermont and reached Albany, New York. They didn't stop until they had taken a boat down the Hudson River. Crummell and another student, Thomas Paul, of Exeter, New Hampshire, were taken by one of the abolitionists out of town. They fled to the Oneida Institute in New York.

History of Canaan relates, "To escape the dangers which threatened their lives and they were real…These young men fled from the wrath that pursued them."

The "Day of the Great Hauling," as it became known, was a sad event in Canaan's history. The town was the scene of a two-day riot where hatred was evidenced and the moral fiber of individuals was torn.

The building sat obstructing the road until September 11, when the select board had it relocated to the corner of the Baptist parsonage field. Of all people, they had Trussell and a smaller crew do the work. To celebrate the completion of the work, a parade of a cannon, fifes and drums proceeded down Main Street. Trussell had the cannon fired at the house of every abolitionist. Breaking glass, loud explosions and rabble-rousing men celebrating was the scene that day. Trussell ended the day with a farewell address, heralding the work and efforts of fighting the "Abolition Monster, that ascended out of the bottomless pit…[and had been] sent headlong to perdition, and the mourners go about the streets."

Eventually, the town reprimanded Trussell for his leadership role in the destruction of the school. No longer the hero or leader, the following year, Trussell was excommunicated from the church and left town. Among those on the church committee were Noyes Academy trustees Timothy Tilton and John Hough Harris.

As for the Noyes Academy building, it sat empty for a while. On March 7, 1839, the building was burned to the ground.

What became of the black students?

Garnet, himself from a family of ex-slaves, became a minister and fought for the temperance movement, abolitionist movement and colonization. He was a leading abolitionist, attending conventions all over the North. His

"Address to the Slaves" was electrifying and moving. He was appointed as minister to Liberia, the goal of colonizationists. He died there.

Crummell attended Noyes Academy with Garnet. After escaping Canaan, Crummell studied theology in Boston and then graduated from Cambridge University in England. He was an instrumental supporter of sending blacks to Liberia. He served as a missionary in Liberia for twenty years. In 1873, he returned to the States to serve as rector of an African American church, St. Luke's Church in Washington, D.C., and wrote two books.

Interestingly, Garnet and Crummell did return to Canaan years later to welcoming citizens who were happy to see they had become successful despite the Noyes Academy tragedy.

A Canaan resident, James Arvin, stated, "Of all the Isms that ever were introduced into Canaan, Abolitionism has done the most mischief. It has arrayed brother against brother in the same church, neighbor against neighbor and engendered more strike and contention than anything else combined."

Media coverage of the Noyes Academy and its demise was prominent in William Lloyd Garrison's *Liberator* pages. The following are clippings of articles that tell the story.

In the October 24, 1834 issue was a notice about Noyes Academy's decision to admit youth of color on equal terms with white youth.

A February 25, 1835 article, "Noyes Academy Open to All without Distinction of Color," stated:

> *The Trustees having heretofore announced, that this Academy is intended to be open to youths of good character without distinction of color, would now inform the Public that they have engaged as Instructor, Mr. William Scales, of the Theological Institution at Andover to carry out the design of the founders, patrons and supervisors of this Seminary… The Academy will be opened for the reception of scholars on the first Wednesday of March, 1835.*

A notice ran in the March 14, 1835 issue from David Child and S.E. Sewall, for the trustees of the opening of Noyes Academy, for "youth of good character, without distinction of color." It announced the appointment of Mr. William Scales, of the Theological Institution of Andover, as instructor and also included a listing of courses of instruction.

Exeter native and former black Noyes Academy student Thomas Paul wrote a letter to the editor about Noyes Academy. It was published in the May 2, 1835 *Liberator*. Paul wrote from Canaan on April 9: "Dear Sir: I

arrived here in health and safety on Tuesday, 31ˢᵗ of March, about 2 o'clock—fatigued, however, with the length of my journey. Mr. Kimball, at whose house I now lodge, received me with that urbanity and welcome, which strangers know so well how to prize."

The article "Canaan Adversity to Noyes Academy" was published in the *Vermont Chronicle* on August 8, 1835:

Not Quite a Riot. We understand that the Academy at Canaan, N.H. has been threatened with destruction. That Academy is under the control of Anti-Slavery men, and is, by public advertisement, open to young men of color, as well as others. It has excited a good deal of interest, and a number of colored pupils are now members. A mob assembled two or three weeks since for the avowed purpose of destroying the building; but as they numbered only about 500, they gave warning of their intentions and adjourned for a week to recruit their forces. At the end of the week, they came together, but in less numbers than before,- -and finally dispersed without doing any damage. We presume the Academy will now go on without molestation. We have always regarded the advertisements of this Academy as slandering most similar institutions in New England— which we believe to be as much open to young men of color as this is. But this is no reason why the young men who resort to it should not be allowed to pursue their course in peace.

The following article appear in the *Liberator* on September 5, 1835:

Removal of Noyes Academy: Three Selectmen of the town of Canaan deny a published statement that the citizens of the town support the school. Then follows an account of the removal of the school. "This is the story of the vote at a Town Meeting, held July 31, at which there was a vote to remove the school, and a committee appointed to discharge that duty, 'the performance of which, they believe the interest of the town, the honor of the state, and the good of the whole community, (both black and white) required without delay.'" Then follows the account of how three hundred people, with ninety to one hundred oxen, carried out the work "with very little noise, considering the number engaged, until the building was safely landed on the common near the Baptist meeting-house..." The account claims the duty to have been carried out in the "spirit of '75," and in memory of those who have fought and fell struggling for liberty.

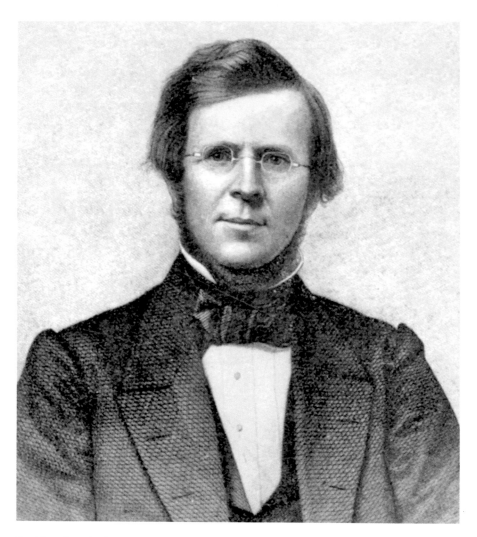

President Oren B. Cheney of Bates College was the son of Underground Railroad agents Moses and Abigail Cheney. *Courtesy of* The Story of the Life and Work of Oren B. Cheney.

The final demise of the Noyes Academy building was described in the March 22, 1839 *Liberator*:

> CANAAN ACADEMY BURNED DOWN. *We learn from the N.H. Statesman that the building formerly occupied by the Noyes' School in Canaan, and which was dragged away from its original site about three years since by a mob, was destroyed by fire on the night of the 9th inst. As it has been in the*

possession of the pro-slavery party ever since the period above referred to, its destruction created much excitement against the abolitionists.

The following winter, Oren Cheney, the son of abolitionist and Underground Railroad agent Moses Cheney, was a student at Dartmouth College and received an invitation to teach for the 1836 winter term at a school in Canaan. The school was not Noyes Academy, which had been destroyed by a mob. The atmosphere was still tense, and the young student teacher had an enlightening experience there. He wrote in his autobiography:

A young Baptist minister took me by horse and sleigh to Canaan on Saturday. We arrived at the house of the agent of the school early in the evening. As we sat at the tea-table, and afterwards before the fire, the whole story was told by the agent of the bringing of "niggers" into town and of the driving them out, with the words added in strong emphasis, "We will not have an abolitionist teach our school."

As my friend left me that evening, I followed him to the door and asked, "What shall I do? I am an abolitionist. I cannot teach the school here." "O," said he, "say nothing about it. It will never be known what you are."

Taking his advice I began the school. Everything went on in silence and pleasantly for about three weeks. But the silence was on my part. I saw the mistake I had made in listening to the advice given me. I could not endure such a non-committal life, and in a quiet way I let my anti-slavery principles be known. The whole town was thrown into excitement as the news spread. The joy of the abolitionists, few in number, can hardly be told. The opposition let me alone, and I finished the school term.

ABOLITIONIST MOVEMENT IN NEW HAMPSHIRE

Chapter 11

OVERVIEW OF THE MOVEMENT IN NEW HAMPSHIRE

The abolitionist movement built momentum when William Lloyd Garrison intensified the antislavery issue by demanding immediate emancipation for slaves in the United States. Garrison didn't want the government to do it halfway or gradually. Abolitionists stood firm against the institution of slavery and this country's government.

Tensions mounted in the 1840s in New England, where abolitionists found they were fighting the church establishment as well as the government. They thought the religious sector would support abolition and refuse to work with the southern factions; that was not the case. The majority of the churches in the North took a proslavery stand because half their church bodies were located in the South. It was a rude awakening as abolitionists were refused to lecture in churches, kicked out of places of worship and faced increasing violence by church members.

The abolitionist lecturers increased their outreach to educate people about the realities of slavery and gain support from the public outside the churches. Parker Pillsbury, a New Hampshire minister turned abolitionist lecturer, aptly called the lecturers "apostles" and likened their work to a religious mission field. Slavery wasn't a political issue in the abolitionists' minds; it was a moral issue.

Wilbur Siebert wrote about the abolitionist movement in New Hampshire and Maine as originating "among a band of courageous, self-sacrificing, religious people little known beyond their own immediate vicinity. Bravely and patiently these antislavery philanthropists bore the scorn, taunts, social ostracism, insults and even blows from the friends of slavery."

New Hampshire was growing quickly and had direct ties to Massachusetts, so it was an appropriate target as a mission field for the abolitionists. From New Hampshire came several New England giants in the abolitionist circles: Stephen Symonds Foster, Parker Pillsbury, Nathaniel Peabody Rogers and John Greenleaf Whittier. Adding to that prominent list were the Hutchinson Family Singers, who used their musical talents to support the movement.

Membership was growing in local New Hampshire antislavery societies that were established in the 1830s, with the first two being in Plymouth and Portsmouth in 1833. The following year, Concord had formed its own with one hundred members. By 1837, there were sixty-two antislavery societies in the Granite State. The first antislavery lecture in the state was in 1835, held at Henniker. Moses Cartland, a Quaker principal of the Clinton Grove School and Underground Railroad agent of Weare, was the guest speaker.

The membership of New Hampshire societies was active in its attempts to change the laws in the state and the country. Petitions flooded the New Hampshire Statehouse calling for the abolition of slavery. In 1838, there were fifty petitions sent by Concord residents alone.

New Hampshire was home to the New England–renowned abolitionist newspaper *Herald of Freedom* with Nathaniel Peabody Rogers at the helm, wielding his pen to promote abolitionism. Other antislavery newspapers in the state were the *Independent Democrat, Independent Democrat and Freeman* and the *Morning Star.*

The braver and bolder the abolitionist "apostles" became, the more violence and mobocracy they faced. Riots, mobs and violence in New York City, Philadelphia and Boston became news in New Hampshire, Vermont and Maine. The abolitionists fought to speak, and the general public didn't want to allow it. These apostles were considered traitors who were stirring trouble that would tear the country apart. They were viewed as troublemakers trying to start a revolution.

In Pillsbury's *Acts of the Apostles*, he wrote from personal experiences. He was on the New England lecture circuit with Frederick Douglass, Charles Remond, William Lloyd Garrison, Rogers, Foster, William Wells Brown, Wendell Phillips, Lucy Stone and others. Pillsbury wrote, "We had met mob after mob; minister after minister, sometimes the direct instigator of the mob; and almost always we had achieved some sort of honorable success; if not triumph."

They traveled from town to town in New Hampshire, Massachusetts and Vermont. They were not always welcomed at the churches and had to find venues for their events. They were often denied the use of meetinghouses

and town halls, but not in every town. Locals would show up at the meetings and try to stop them. A review of the receptions they faced shows that it didn't matter how far north people were, they still didn't want the country to be divided.

At Northfield, the Reverend George Storrs was attacked when he attempted to deliver an antislavery lecture. He proceeded to drop to his knees and pray but was dragged by a deputy sheriff out of the building. Storrs was charged with being a brawler and disturbing the peace. He faced trial but was acquitted. A few months later, Storrs lectured in Pittsfield and was arrested again. This time, he went to court and was sentenced to three months in prison, but the sentence was eventually dropped.

At Exeter, abolitionists held their meeting at the Methodist meetinghouse. Even so, Pillsbury wrote in his book that the local Congregational minister forbid them to speak in his presence by using "language absolutely abusive."

Stephen Foster faced a mob at Franklin in November 1841 and sent a letter to the Congregational church minister that he also had published in the *Herald of Freedom*. He wrote:

> *I sit down to address you relative to the recent outrage that was perpetrated upon an anti-slavery meeting in your parish, and by persons under your immediate supervision…But a mob among Christians, under the very eye of the pulpit, and in defence of that pulpit fills the mind with astonishment—It is sad proof that the pulpit and mob are identical in spirit and coincident in their aims!*

For the annual meeting of the Grafton County Antislavery Society, neither Dartmouth College nor Hanover churches would allow its members a meeting place. They finally found a building and began their meeting, but college students crowded in so they could harass the participants. The students clapped, hooted, hissed, scraped their feet and whistled—anything to disrupt the society's business.

At Hancock, the local parishioners were warned by their pastor not to attend any of the antislavery meetings. Some did attend, but so did the opposition who attempted to disrupt the meetings. Pillsbury wrote about one man who "came in with a great club in his hand and marched up to the altar and with mock solemnity took a seat before it. The young mobocrats laffed [*sic*]. The abolitionists took no notice of him…he got sick of sitting there and marched out." Things turned ugly when it was Foster's turn to speak, and the mob threw large rocks at the front door and broke windows.

What the opponents in all these incidents failed to realize was that the abolitionists were more determined and devoted to their mission and could not be scared off. What Pillsbury and the abolitionist lecturers found was that there were people who did want to hear them. They did have productive meetings even if mobs tried to shut them down.

The Reverend Samuel May of Connecticut was a popular abolitionist lecturer around New England. He was one of the founders of the New England Anti-Slavery Society and the American Anti-Slavery Society and also was a close associate of Garrison. May's first visit to Portsmouth was in 1834, when he was scheduled to give two lectures. But after the first one, the church trustees asked May to cancel the other one because of opposition against him. May refused.

In Northampton in 1841, Pillsbury and Foster asked permission of the minister to use the church for an antislavery meeting. The minister said, "I have heard of you and Foster and I want nothing to do with you. In your *Herald of Freedom*, you abuse the ministers."

At West Chester in 1841, a crowd tried to provoke Pillsbury and Foster and attacked them as they were sitting in their carriage. The crowd damaged the carriage, which had to be repaired, and the duo left town.

The opposite reception occurred in Dover. The abolitionist meetings were productive, and Nathaniel P. Rogers reported in the *Herald*, "We have never attended a meeting of any character so splendidly sustained and so orderly, voluntarily and beautifully conducted."

The work of these stalwart abolitionists inspired others to stand up for their beliefs. In Concord, a group of women who were members of the South Congregational Church decided to be proactive and get their church to stop supporting the slavery institution. But in the mid-1800s, women were not permitted to pray or speak at public assemblies. Their opinions had to be shared in another form: the written word.

On January 16, 1841, Louisa Wood, Esther Currier, Mary Ann French and Sarah Pillsbury submitted a letter to the minister, Reverend Daniel Noyes, stating their displeasure with the church and government's support of slavery:

> *Three million of God's immortal children, our brethren and sisters are held and used among us as chattels personal, and bought and sold as brute beasts…Thus a cloud of frightful, perpetual night is drawn over millions of souls in this land of Bibles and professed Christian ministers and churches. With such views and feelings we can no longer recognize you as a*

Christian church while as a body you continue in your present position of silence to the wrongs of the slave.

These women turned the tables on the church establishment and declared that they refused to see it as an authority until it changed its ways. They excommunicated the church from themselves.

Milford Convention

Even in towns that had large abolitionist support, there was always someone trying to stop the meetings. Milford's abolitionists, led by Leonard Chase, hosted many meetings and invited Garrison, Phillips, Rogers, Foster, Pillsbury, Douglas and Remond to them. George Ramsdell and William Colburn, authors of *The History of Milford New Hampshire*, wrote about the abolitionists in town:

> *The Milford abolitionists with Leonard Chase as the leader were well known and respected citizens, and most of them had, a short time before, withdrawn from the Congregational and Baptist churches, and had received and taken in the name of "come-outers." These aggressive pioneers in the anti-slavery cause took issue with the churches because of lukewarmness or supposed lukewarmness upon the vital question of human slavery.*

A successful convention was held on January 4, 1843, at the Old Meeting House despite the antics of Milford resident Nathaniel Coggin. Coggin locked the church doors and attempted to prevent the meeting by obtaining the keys and nailing shut the windows and doors. That didn't stop the abolitionists. Members of the church broke open the doors, and the meeting was held.

Frederick Douglass in New Hampshire

Famous fugitive slave Frederick Douglass spent a lot of time in New Hampshire lecturing and also visiting with close friends such as Moses Sawyer, Moses Cheney and John Greenleaf Whittier.

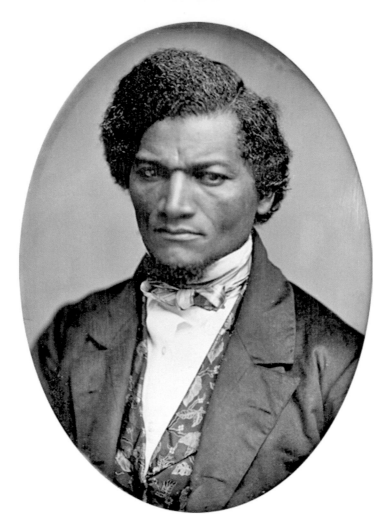

Former fugitive slave and famous abolitionist Frederick Douglass spent a lot of time in the Granite State with friends and on lecture tours.

In 1842, only recently escaped from slavery and just twenty-five years old, Douglass arrived in Pittsfield to lecture at a church at the request of the Massachusetts Anti-Slavery Society. He encountered northern prejudice on his way to Pittsfield when he had to ride on the stagecoach roof because of his race.

Though he was invited to Pittsfield, Douglass received a cold reception at the home where he stayed. He gave his lecture, but no one applauded. When the meeting broke for lunch, Douglass was left alone and not invited anywhere for a meal. The local tavern refused to serve him.

Douglass went back to the church to wait for the second half of the meeting. The story—as recorded on the historical marker commemorating Douglass's visit—goes that Douglass sat on a stone wall in the rain and waited there until his evening lecture. Finally, Moses Norris, a proslavery senator, invited Douglass to his home. The Norris family was unfriendly at first, but soon Douglass won them over. By the end of his evening lecture, the two families he had met were fighting over where he should stay. The meetings were well attended, and the residents of Pittsfield changed their minds about Douglass.

Douglass also was among numerous abolitionist lecturers who frequented Portsmouth's Temple on Chestnut Street. The Temple was a one-thousand-seat lecture hall that opened in 1844. William Wells Brown, Douglass and Remond were black abolitionists who often held meetings there. Soon after it opened, Douglass addressed the Portsmouth Female Anti-Slavery Society in December 1844. He returned to the Temple in 1862, having established himself as a famous abolitionist orator and author.

George Thompson's First Foray in America

William Lloyd Garrison invited the famous English abolitionist George Thompson to visit America and infuse energy into the abolitionist movement with his flair and reputation. Many people took offense to Thompson's arrival, especially since his presence incited crowd agitation and mobocracy.

On his first tour in New England, Thompson was welcomed by Rogers in New Hampshire. Many accounts have been written of his Concord mob experience. In an unpublished memoir by Rogers's son, Daniel Farrand Rogers, the story was told from a personal perspective:

> George Thompson, a famous Englishman who had been viceroy to India and was a member of the English parliament, an orator and a good deal of a man, the co-worker with Wilberforce, Clarkson, Sturges and a host of philanthropic reformers in the work of British Emancipation in the West Indies, was invited to come to America to help the cause of emancipation in this country. Garrison, Phillips, and Quincy in Boston, the Childs and the Tappans in New York, the Motts and Isaac T. Hopper and others in Philadelphia,—these and many others I forget were just beginning to

agitate against the vile old system. They invited Thompson to come here. He was greeted with bitter hate by the pro-slavery spirit of the country and accused of coming here to stir up strife between the two sections of the United States.

He came to Concord, the capital of New Hampshire. The mob headed by a deacon of the South Church of that town,…heard that he was secreted at the home of George Kent…and they went roaring up there.…reaching the front of the house, demanded Thompson…Aunt [Anne] Kent came to the balcony and told them Thompson was not in the house. He had passed out the back door and hid in the woods…

Whittier, the Quaker poet, had been there with Thompson and believing the Englishman was safely hid, Whittier started down the street toward town. The mob saw him and suspecting it was Thompson, gave chase… Seeing a cabin door open, where a woman was washing, he begged her to let him in…She took him in and as the angry mob reached her door she planted herself on the step with uplifted mop, vowing she would brain the first man that crossed her threshold. The leaders of the riot probably had an idea that she would make good her threat and no doubt the humor of the occasion touched some of them,…the mob burst into a laugh and went to town.

Thompson, Whittier and Garrison then came to Plymouth, and to my father's house. Here they found welcome and strong sympathy. Some meetings were held in the town for the pro-slavery bitterness had not tainted the small New Hampshire villages as yet. Thompson was delighted with the new acquaintance he made in N.P. Rogers and told his Boston friends that "that was the most delightful man he had met in America." The most important fact to this narrative that came of this visit was that my father and mother became active, earnest self-sacrificing Abolitionists.

Chapter 12
THE ABOLITIONIST APOSTLES

Parker Pillsbury called his comrades in the abolitionist movement "apostles" and the abolition of slavery their religion; their mission field was every northern state in the Union.

New Hampshire natives were prominent in the movement, working hand in hand with Garrison. Researching the abolitionists of the era in New England, you create a sociogram of people who were abolitionists and some who also were Underground Railroad agents. John Greenleaf Whittier was related to Moses Cartland. Whittier stayed in Center Harbor frequently and was acquainted with John Coe, an Underground Railroad agent. Cartland and Moses Sawyer were friends. Sawyer and Frederick Douglass were close friends. Speakers on the lecture circuit traveled together and socialized and relied on one another for encouragement and inspiration.

Nathaniel Peabody Rogers

Rogers grew up in Plymouth, New Hampshire; graduated from Dartmouth College in 1816; and married Mary Porter Ferrand of Burlington, Vermont, in 1822. They resided in Plymouth for the next twenty years in the same house in which he grew up. Rogers had a successful law practice for years and was heavily involved with the Plymouth community and schools there. He joined the abolitionist movement, which changed his life.

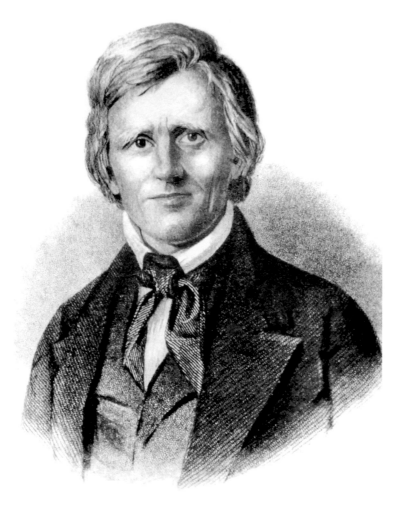

Nathaniel Peabody Rogers was a well-known abolitionist, Underground Railroad agent and editor of the *Herald of Freedom*. His abolitionist writings inspired people to join the fight against slavery. *Courtesy of Rogers Family Collection, Michael J. Spinelli Jr. Center for University Archives and Special Collections, Herbert H. Lamson Library and Learning Commons, Plymouth State University.*

"The Rogers family suffered greatly for their activism in Plymouth having been excommunicated from their church for their efforts. But Rogers for his part, wrote back to the church informing them that indeed, he was excommunicating them for 'failing to live up their pretensions,'" stated a 2008 *Plymouth Record Enterprise* article.

He gave up his legal practice when he became the editor of the *Herald of Freedom* and moved to Concord. His antislavery newspaper published

bold articles critical of slavery and the church's stance. His articles were also published in the *New York Tribune,* of which his friend and fellow New Hampshire native Horace Greeley was editor.

Rogers traveled the abolitionist lecture circuit with Garrison, Pillsbury and Foster. He promoted the Hutchinson Family Singers by publicizing their concerts in his newspaper.

According to Douglass, Rogers was "one of the most brilliant and gifted writers of that day. He was an Abolitionist of the Abolitionists, and in thrilling words and at the very top of his sublime enthusiasm in that cause, he hailed with welcome the Hutchinsons, as did all Abolitionists, regarding them as a splendid acquisition to that then unpopular and persecuted cause."

Rogers was instrumental in the growth of the abolitionist movement in New Hampshire, and when he died young, his loss was deeply felt by all of New England.

Hutchinson Family Singers

They were known as America's first protest singers, but originally the Hutchinson Family Singers performed songs about country life and social issues. Parents Jesse and Mary Hutchinson were farmers in Milford, New Hampshire, but promoted their children's talent early on. All thirteen of their children sang with the group at one time or another. The main singers were Jesse, Judson, John, Asa, Abby and Joshua. They performed at events for temperance and women's rights groups and at prisons.

Their acquaintance with abolitionist Rogers began their career as protest singers. Rogers served as an advisor and friend, promoting them in his newspaper. After the spring of 1844, they began focusing on the abolitionist cause because of Rogers's advice to perform songs about slavery to educate people.

Douglass wrote, "More than fifty years ago they were introduced to the country from the granite hills of New Hampshire, through the columns of *The Herald of Freedom,* by Nathaniel P. Rogers."

The Hutchinson Family Singers performed music composed by sons Judson and Jesse. They traveled throughout New England and England. Their songs educated, not only entertained, and the abolitionist cause benefited from their outreach. They played a large role in the social revolution. They were one of the best-known musical ensembles of the nineteenth century.

Stephen Symonds Foster

Stephen Symonds Foster was born in Canterbury. He studied to become a missionary, attended Dartmouth College and got involved with the abolitionist movement. He was known for his aggressive style and his blatant verbal attacks on the church establishments. Foster helped form the New Hampshire Anti-Slavery Society and belonged to the "New Hampshire radicals" group within the American Anti-Slavery Society. Foster wrote antislavery tracts and was the author of *The Brotherhood of Thieves: A True Picture of the American Church and Clergy.*

Pillsbury wrote that Foster "encountered more opposition and violence than any other agent in the lecture field." James Russell Lowell called him "a kind of maddened John the Baptist."

By Foster's own estimation, he was dragged from churches twenty-four times, thrown out of a two-story building twice and was immobile after a kick in the side at a Baptist meeting. He spent at least a dozen stays in jail in both New Hampshire and Massachusetts.

Wilbur Siebert wrote that Wendell Phillips had regarded Foster's work as responsible for getting New Englanders' attention because "it needed something to shake New England and stun it into listening. He was the man and offered himself for martyrdom."

In the early 1840s, Foster toured New Hampshire, Maine and Massachusetts with Pillsbury. Foster married Abby Kelley, who had made a reputation as an abolitionist active from the 1830s to the 1870s.

Abby Kelley Foster was born and raised in Massachusetts in a Quaker family. She got into teaching, and after a Garrison lecture, she joined the abolitionist movement. Kelley joined the Female Anti-Slavery Society of Lynn, Massachusetts. She became involved with the National Anti-Slavery Society, distributed petitions, raised funds and participated in conferences. In 1838, Kelley gave her first public speech at the women's antislavery convention in Philadelphia, a bold move since women were not allowed to speak in public forums.

She worked closely with Garrison and was involved with fundraising and abolitionist events. She married Stephen. Their home in Massachusetts, known as Liberty Farm, was a safe house for fugitive slaves. They both worked for the abolitionist cause and for women's suffrage.

Parker Pillsbury

Born in Massachusetts, Parker Pillsbury moved to Henniker and called New Hampshire home the rest of his life. He farmed but also became a Congregational minister and served at a Loudon church. By 1840, Pillsbury was stirring up trouble in the church, promoting his antislavery beliefs. His preaching license was actually revoked because of his criticisms of the church's slavery stance.

He joined an ecumenical Free Religious Association, so he continued preaching throughout New York, Ohio and Michigan. But his calling was to the abolitionist movement, and he returned to New England to work for the cause. He was a lecturing agent for the antislavery societies of New Hampshire and Massachusetts, helping to organize events and conventions.

Pillsbury traveled with Foster, Rogers, Garrison, Douglass and others. Besides recording the mission of the abolitionists, he was known as an "agitator" and fierce lecturer himself.

Pillsbury published his abolition memoirs, *Acts of the Anti-Slavery Apostles*, in 1883.

Wilbur Siebert referred to Pillsbury as the

> *gifted son of New Hampshire…a very powerful speaker. He had a vivid imagination and could picture the atrocities of the slave system and the guilt of its supporters in their true light. His speeches, adorned with imagery, were very fascinating; his manner, solemn and earnest, was most impressive. To intensify his utterances he exhibited shackles, chains and a terrible whip whose throngs were red with blood drawn from the backs of slaves.*

John Greenleaf Whittier

John Greenleaf Whittier was raised in Haverhill, Massachusetts, and his parents had a family farm there for years. He worked in the newspaper business in Haverhill, Newburyport and Essex, but on the side, he worked on his poetry.

He became involved with the abolitionist cause in his late twenties and started out by publishing a pamphlet promoting emancipation. He spent time where the abolitionist movement was growing quickly in Pennsylvania.

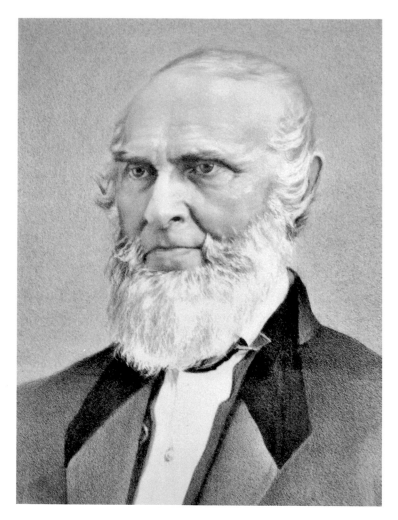

John Greenleaf Whittier was the famous poet in the nineteenth century who championed the abolitionist cause, using his poetry to further it. He was close to New Hampshire abolitionists and Underground Railroad agents. *Courtesy of Center Harbor Schoolhouse Museum.*

Whittier witnessed mobs and traveled through the southern states, talking to southerners and inspecting slave auctions, slave pens and housing. This information gathering fueled his passion for the cause, and his poetry focused on the subject of the oppressed slaves. *Harper's Weekly* began publishing in the 1850s, giving Whittier a terrific forum.

He was known as the poet who addressed major issues through his verse. Whittier spent summers in Center Harbor with family friends; the

lake was a retreat for other poets like Celia Thaxter and Lucy Larcum. Near Lake Winnipesaukee, there is a tree called the Whittier Pine in honor of the famous poet. While at Center Harbor, he spent time with John and Lavinia Coe, who helped fugitive slaves at their Coe Mansion.

Whittier worked with Underground Railroad agents in Massachusetts and New Hampshire, helping move fugitives northward. His cousin Moses Cartland in Lee, New Hampshire, was an agent too.

Whittier settled in Massachusetts for a while, serving as a newspaper editor in Lowell.

John Greenleaf Whittier was highly respected and considered a national hero.

Littleton Abolitionists

In the northern town of Littleton, about an hour south of the Canadian border, a small abolitionist group thrived because of the efforts of Edmund and Mary Carleton, Nathaniel Allen and Erastus Brown. They tried to change the local church's stand on slavery. These abolitionists

The Littleton Congregational Church on Main Street in Littleton was the scene of Nathaniel Allen and Erastus Brown being arrested during church services. They were abolitionists attempting to speak on behalf of the slave population and spent over two weeks in jail. *Courtesy of* History of Littleton, *3 vols.*

were considered radicals for standing firm against slavery. They suffered persecution and mistreatment for sharing their beliefs and were silenced.

The Littleton Antislavery Society had a small membership but sponsored antislavery lectures in town. The first was held in 1840 and was Pillsbury's first antislavery campaign in the Granite State. *History of Littleton* stated, "From that time Anti-Slavery found footing in Littleton beyond any other town in all the mountain district of the Granite State. The *Herald of Freedom* had more subscribers there than Conway, Haverhill or Lancaster."

The Littleton Society hosted a huge antislavery convention in 1841 with major abolitionist Garrison, Colonel Jonathan Miller of Montpelier, Dr. John Dewey of Guildhall and others.

After the convention, Edmund felt it was time that the local church made decisions about abolition. The Littleton Antislavery Society requested a meeting of the church to determine what action the church would take on the subject of slavery. Its members wanted the Congregational Church to sever relationships with any church allowing slaveholders into its membership. Carleton's resolutions and requests were ignored by the minister.

Tolerance of the abolitionists in Littleton began to wane. Pillsbury visited Littleton again in 1842 but was not well received. The minister would not allow him to lecture in the church. Allen pleaded for permission, but it wasn't granted. People didn't want to hear from the radicals.

Chapter 13
JAIL TIME FOR ABOLITIONISTS

Certain abolitionists, following Foster's example, began a practice of attending church services and requesting to speak about slavery. The requests were denied again and again.

On August 16, 1842, Littleton abolitionists Nathaniel Allen and Erastus Brown requested to speak at the Littleton Congregational church. The minister refused adamantly, and Edmund Carleton requested that they be allowed to speak. The minister and some prominent church members ordered Allen and Brown to cease and desist. When they continued speaking, several church members grabbed them, each falling limp, and they were dragged out of the church. They were arrested and imprisoned. Charges were "disturbing religious worship."

They faced a trial, and Carleton, a lawyer, defended them. The trial had a large audience of Littleton citizens. Brown and Allen were well known, and many spoke on their behalf. Allen wrote to Pillsbury, "The Littleton people, outside the church…think it was the most disgraceful prosecution ever enacted in the town."

The men were found guilty and sentenced to pay a fine or be imprisoned in the county jail. They chose jail and were taken to the Haverhill County Jail, which had been the focus of media attention in 1805 when one of the inmates, Josiah Burnham, murdered two other inmates. Burnham was hanged in 1806, drawing thousands of people to Haverhill for the event. Brown and Allen served sixteen days in prison. The conditions were horrible—no beds or pillows, filthy and overrun with rats.

The old gaol at Haverhill was where abolitionists Nathaniel Allen, Erastus Brown and Stephen Symonds Foster were imprisoned. Allen and Brown wrote of the horrible conditions there. The small cells housed two to three inmates and were dark and filthy with rodents. The jail was originally built in 1794 and was located on Court Street, beside the courthouse; the Bliss Tavern was at the intersection. *Courtesy of Michelle Arnosky Sherburne. Haverhill Jail privately owned by Bob Adams.*

Brown wrote to Pillsbury:

Haverhill Jail, August 30, 1842
Brother Pillsbury—I greet you through the bolted doors and grated windows of Grafton county jail…

> *I cast my eyes around, and contrast the dismal aspect of my half-lighted, barred and bolted cell (where, as I am assured, deeds of darkness have been indeed done, for two men were murdered, we are told, in this room, by a third named Burnham, all three confined only for debt)...*
>
> *We are in a cell with a young man who tells us he has been confined more than a year on a charge of theft, of which he declares he is innocent, and I believe he is. He has been in this cell four months and says it is a heaven compared with the loathsome den underneath where he lingered eight months! He was only removed from it on account of declining health. It is sad to hear the low, murmuring sound of human voices from distant cells, as they occasionally come up to our room through a small hole in the huge barred and bolted door or grated window, through which the scarcely audible voices can be heard as if in supplication from the lower world!...*
>
> *Each morning I rise from my pallet of straw or rather of chaff and vermin.*

Allen also wrote to Pillsbury: "If we had but some clean straw and a block of wood for our heads it would add very much to our comfort." Allen's wife learned of his conditions in his letter to her: "True, our situation, filthy and over-run with vermin though it be, is more tolerable than I expected."

After serving their sentences, Allen left town in 1844 and Brown in 1845. Allen moved to Lowell, Massachusetts, and died in 1873; Brown lived in Milford, New Hampshire, until his early death in 1854. The antislavery society lost strength after they left.

The History of Littleton aptly honored Allen and Brown:

> *It is seldom that any cause has received a more unselfish support than these men gave to anti-slavery...Yet they gave time and money and sacrificed the good opinion, friendship, and patronage of their neighbors, to advocate the emancipation of thousands of human beings they had never seen, of whom they only cared to know that they wore the chains of slavery.*

Foster's Jail Time in Haverhill County Jail

Pillsbury wrote in *Acts of the Apostles* that Stephen Symonds Foster attended Dartmouth College and was recruited for military service. Foster denied service on the basis of his beliefs and "was arrested and dragged away to

jail. So bad were the roads that a part of the way the sheriff was compelled to ask him to leave the carriage and walk."

The *Woodsville News*, a local newspaper in Haverhill, ran a story in 1914 about the Haverhill County Jail, noting that in 1832, "Stephen Foster was imprisoned there for holding the doctrine of non-resistance and refusing to join a military company while a student at Dartmouth College. Ten years later, Nathaniel Allen and Erastus Brown were confined there for uttering abolitionist sentiments."

At the Haverhill County Jail, Foster's fellow inmates were poor debtors, thieves, murderers and other felons. Foster "wrote and sent to the world such a letter as few but he could write, awakening general horror and indignation wherever it was read and a cleansing operation was forthwith instituted. The filth on the floor was found so deep and so hard trodden, that strong men had to come with pick-axes and dig it up."

UNDERGROUND RAILROAD EFFORTS

Chapter 14
AGENTS AND THEIR CONTRIBUTIONS

People who were part of the Underground Railroad network were aware that they were only a small part of a larger picture. The consensus was to say, "My part was very small and I do not have much information." They realized they were one of hundreds helping one slave get to his or her ultimate destination. Thus, their role was small.

People who had helped fugitive slaves were bound by secrecy during the network years and continued to keep quiet just in case there would be retribution for their illegal actions. There must have been an understanding among agents on the protocol of divulging information. In the letters to Siebert in the late 1890s and early 1900s, former agents kept the "code." Among those who were active in helping fugitives or whose fathers were, a common practice was not naming fellow agents directly.

After the Civil War and Reconstruction era, towns all across the United States were having their histories written. Most town histories were originally published in the late 1890s. Information about the Underground Railroad network was not mentioned. People in the North and South were trying to forget that bad part of the country's past. The mindset was that if they didn't talk about it, it would fade away into obscurity.

The subject of slavery and helping slaves was negative after the Civil War. Northerners didn't want to focus on anything negative. If a grandfather owned slaves, that information would taint his reputation in the twentieth and twenty-first centuries. The same goes with helping fugitive slaves. It was

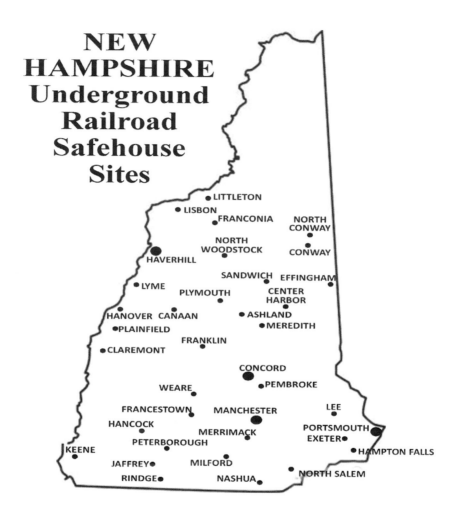

New Hampshire had fugitive slave traffic coming from Boston, Maine and the coast. *Graphic created by Michelle Arnosky Sherburne.*

taboo to talk about it, so it was better left unsaid. It was the family secret that could give the family a bad reputation.

Underground Railroad research has always been difficult because of the code of secrecy due to its illegal nature. People didn't talk about helping fugitives or admit to involvement. Eventually, letters, diaries, journals and books hidden in house walls or filed in boxes in the attic will be found and information will be revealed. Boxes cemented in cellar walls will eventually

be located when renovations are made. In the past one hundred years, so many Civil War artifacts and documents have surfaced. The same goes for Underground Railroad information and slave accounts.

New Hampshire's network may not have documentation for every instance. But there are letters, journals and references about people who helped in the Underground Railroad. Local tradition has kept some of the history alive. We will examine alleged agents in the state, but not all have documentation of their efforts. Some are from local tradition and family stories, and some information may be conjecture.

Jonathan Pattee—North Salem, America's Stonehenge

Mystery Hill in North Salem is known as America's Stonehenge. It is a maze of man-made chambers, ceremonial meeting places and an accurate astronomically aligned calendar. It is one of the oldest man-made sites in the United States at over four thousand years old.

In an *NHToDo Magazine* article, Chris Zerillo wrote, "First recognized for its pre-historic importance in 1893 by Professor Hugh Morrison of Dartmouth College, America's Stonehenge has since been studied by archaeologists, historians and students from numerous universities and colleges." It has been privately owned and open to the public since 1958.

Archaeological excavation at the site has uncovered a plethora of artifacts including stone tools, pottery, ancient scripts and housewares. Manacles were found, possibly removed from slaves who used the site as a stop on the Underground Railroad.

Mystery Hill was owned by abolitionist Jonathan Pattee, a farmer who lived on the site from 1826 to 1848. He built a home over a portion of the stone ruins on the site. In the Wilbur Siebert files, a 1935 letter from Elsie Conley of Westville, New Hampshire, refers to the Pattee Caves' use as a safe house for fugitive slaves. Conley wrote that her father's farm was near the Pattee Caves and "they were used in the old days for hiding slaves. The tale is that the slaves were brought from Boston to the New Hampshire line, then taken up the Spiket River, which is just over the hill from the caves. Then on to Canada."

Edmund and Mary Carleton—Littleton

Edmund and Mary Carleton spearheaded the Littleton Anti-Slavery Society and worked for the abolitionist cause, but behind closed doors, they helped fugitive slaves. Their house on the Apthorp Common area north of Littleton was a busy station.

Originally from Haverhill, Edmund moved to Littleton and built a house near the Ammonoosuc River. Before marrying Edmund in 1836, Mary was a teacher at Concord Academy and socialized with abolitionists there. Her passion against slavery intensified.

Edmund was a successful lawyer in Littleton. His persistence regarding abolition cost him his law practice, destroyed friendships and wrecked his reputation. The *Gazetteer of Grafton County, N.H.* wrote that Edmund's abolitionist beliefs "placed him in an attitude of hostility to the dominant party in his church, and largely deprived him of his influence in the community. Still he kept the course marked out."

He closed his law practice and got into the lumber business. He was appointed by the state to direct the work of building a road through Franconia Notch, now a popular tourist area. He had a large collection of issues of the *Liberator* by William Lloyd Garrison, which years later the Library of Congress bought from him.

History of Littleton, N.H., Volume 1 by James R. Jackson stated, "Many a person came this way from Haverhill in order to more effectually avoid pursuit. Often the frightened runaway was required to remain for days at Mr. Carleton's before it was considered prudent to continue the journey."

The Carleton house sits on a small knoll beside the river, and there is a steep twelve- to fifteen-foot bank. According to local stories circulated and in *Historic Glimpse of a North Country Community, Littleton, N.H.*, Mildred Lakeway wrote of a hidden tunnel space behind part of the cellar wall. Older residents remember one side of the cellar wall could be removed, and a tunnel went from the cellar and exited on the nearby bank. The woods around the house down to the river provided cover for sneaking fugitives in and out.

Lakeway wrote, "The Carleton House is a present reminder of those early days of bitter struggles over the 'run-away slaves' who came to Littleton, our town, for help and protection."

It was recorded that the Carletons received fugitive traffic from Haverhill. Another source was a regular route from Plymouth through Franconia Notch to Littleton. They then sent the fugitives across the river to Lunenburg or north to Derby, Vermont.

UNDERGROUND RAILROAD EFFORTS

Edmund Carleton's work helping fugitives has been documented in a William Lloyd Garrison letter about a fugitive who showed up at an abolitionists' convention in Boston. Garrison documented that the slave's journey through New Hampshire was interrupted by running into his owner. Garrison wrote to Nathaniel P. Rogers of Concord, who had helped this fugitive on this journey, on June 7, 1842:

At the time of our late New England Convention, a young colored lad came to one of our meetings, in the capacity of a runaway chattel; and as he was anxious to follow the North star even into Canada, (the sun of republican liberty being too brilliant for his weak vision to gaze at), a collection was taken up for him, amounting to about fourteen dollars, to aid him on his way. In addition to this sum, our colored friends here gave him some six or seven dollars. He was also furnished with a trunk, and a good supply of clothes. He then took his flight for Canada, via Concord, but, to our surprise found his way back to this city yesterday.

His statement is as follows. On arriving at Concord in the stage, he saw you, from whom he received a note, (which I have now in my possession), to Denison R. Burnham, of Plymouth, and to Edmund Carleton, of Littleton, soliciting their friendly offices, &c... The next morning, he resumed his journey in the stage,... when, on stopping at the tavern, who should open the door of the stage, but his southern master! He was seized by the collar, and hurled by his master violently to the ground, who swore that he would make an example of him on his return to the South. He immediately regained his feet, and ran at the top of his speed near a river, pursued by his master and two or three others, but succeeded in making his escape by plunging into a pine thicket, leaving behind him his trunk...

After wandering about for some time, greatly afflicted and dismayed, he got on the right road to Nashua, to which place he travelled, where he got into the cars, and came to this city.

The boy tells his story very artlessly, and appears to be honest and sincere... The only part of it that seems to be remarkable is that coincidence of meeting his master, so far up in New-Hampshire. But, according to the statement of the lad, he is an opulent and very extensive slaveholder, and accustomed every summer to visit the North. Probably he was wending his way to the White Mountains...

Perhaps he had arrived at Littleton, and a line from you to friend Carleton may be the means of our obtaining his trunk and money.

Nathaniel and Armenia White—Concord

The first public park in Concord was built in memory of Nathaniel White, a successful businessman and abolitionist. His wife, Armenia, donated twenty acres to the town in 1884 for White Park. Nathaniel was a native of Lancaster, New Hampshire, and his wife, Armenia, was raised as a Quaker in Mendon, Massachusetts. They married and had eight children, living in Concord most of their lives.

Their family farm, known as White Farm, on Clinton Street was established in 1846 by Nathaniel and Armenia, who were active in the Underground Railroad. Their home was a safe house for fugitive slaves.

Armenia and Nathaniel joined forces for three major causes: abolitionism, women's suffrage and temperance. They organized the Concord Universalist Society and supported the construction of the church. Thanks to the Whites, Concord's cultural base was enhanced by White's Opera House, which was four stories tall and cost $60,000 to construct. It burned in 1920.

Nathaniel was involved in many successful business ventures. He owned and operated a number of hotels in Concord and also Chicago and operated the first stagecoach service between Concord and Hanover. He was instrumental in the city's growth and served in 1850 as a director of the Concord Gas Light Company, which provided the first gas lighting to the main village. He served on bank boards and helped with the railroad and other community efforts. He was involved in politics, serving in the state legislature in 1852 and also running for governor once.

Armenia had her own causes that she supported wholeheartedly, and she left her mark on the state. She established the Centennial Home for the Aged; contributed to the New Hampshire's Orphans Home in Franklin; and was a member of the New Hampshire Prisoners Aid Society, the National Indian Association and the New Hampshire Society for the Prevention of Cruelty to Animals.

Nathaniel died in 1880, on record as one of the wealthiest men in New Hampshire.

Lyme's Town Network of Agents

In the nineteenth century, Lyme was on the heavily traveled Grafton Turnpike. Construction began on the turnpike—which was sixty-six feet wide—in

The Lyme Cemetery is across Route 10 from the Lyme Congregational Church and the site of this gravestone for Deacon Irenus Hamilton, one of the Underground Railroad agents in town. *Courtesy of Michelle Arnosky Sherburne.*

1804, and it opened in 1806. It ran from Orford, Lyme, Canaan, Grafton and Danbury to meet with the Fourth New Hampshire Turnpike in Andover.

Lyme was a hotbed of secret Underground Railroad activity moving fugitive slaves northward. A number of agents lived in town, so one would assume Lyme as a community was supportive of the fugitive traffic moving through. But slavery was a hot topic in town, and the issue almost tore apart the Congregational church. Most residents didn't support the abolition of slavery. The secret network that has been discovered supports the idea that

At one end of town is the resting place of Calvin Fairfield in the Lyme Cemetery, and at the other end of town is his house that was an Underground Railroad safe house. *Courtesy of Michelle Arnosky Sherburne.*

discretion was necessary in this small town on the Connecticut River. The example of Lyme's independent mini-network was preserved in a letter written to Wilbur Siebert.

As early as the 1830s, Lyme had a steady flow of fugitives being brought to agents here from Canaan that received fugitive slaves once a month. Canaan agent James Furber traveled once a month with fugitives to Lyme. The mini-network passed them from house to house in town, and then two options were available to them: they were either transported over the river into Thetford, Vermont, or taken by wagon north to Haverhill.

Caroline Fairfield of Lyme wrote in 1935 to Mildred Paulsen, granddaughter of Haverhill's Underground Railroad agent Timothy Blaisdell, about the network. The letter is now in the Wilbur Siebert collection. Fairfield shared her husband's recollections of Lyme and the Underground Railroad. Her husband was Payson Fairfield, and his father, Calvin Fairfield, was in the network:

> *To Mrs. Paulsen:*
> *Lyme was in those days an "Abolition" town from the minister down to the plain man voter. The law requiring fugitive slaves to be returned to their owners was bitterly opposed here. My husband Payson E. Fairfield who was born in Lyme in 1841 and all I know about it, is stories I've heard him and the minister's boys and Dea[con] Hamilton's boys tell of their experiences as runners from one station to another of [the] "Underground Railway." The old parsonage was the first station in the village. Father F's [Fairfield's] was next, and then Dea. Hamilton's, each of these a little south of the meeting house. From some one further down river would be a*

This is a map of Lyme Plain from H.F. Walling's 1860 Grafton County, New Hampshire maps. On the road on the left-hand side are the homes of Reverend E. Tenny Parsonage and C.P. Fairfield, who were part of the Lyme Underground Railroad network. Also, the T. Hamilton house, which was where Irenus Hamilton received the relay of fugitives, is located on the upper right-hand side of the map. *Courtesy of Dave Allen at www.old-maps.com, P.O. Box 54, West Chesterfield, NH 03466.*

message that on such a night one or two or three negroes would reach the house of Rev. Dr. Tenny after dark, would he be ready to care for them till it was safe to send them on toward Canada. Then the fun for the lads here began. The next station was up river north of our village the boys could drive the darkeys along if all was quiet in a hay rack with straw beneath them and over them. Most of them got safely off but one or two were found in hiding and taken back South.

A recap of this Lyme network: word was sent to Reverend Erdix Tenny of an arrival of fugitives. The fugitives were taken to Tenny's parsonage. His sons would take them to Calvin Fairfield's house, a couple houses north. Payson (Calvin's son) and the Tenny boys would sneak them to Irenus Hamilton's house at the western end of the town common. To get them out of Lyme, the runners and Hamilton would hide them in a hay wagon, and depending on safety issues, the wagon would either be taken north to Haverhill or cross into Vermont to Thetford agents.

All in the Family

Tenny was a Vermont native. He graduated from Middlebury and Andover College. In 1831, he moved to Lyme. He married twice; his first wife died young, and then he married Mary Hamilton, Dr. Cyrus Hamilton's daughter. He was the minister of the Lyme Congregational Church from 1831 to 1867, with over six hundred new members joining during his tenure. He was popular and respected in town. During his term, the slavery issue almost divided the church, but Tenny was the calming force.

Irenus Hamilton, Tenny's brother-in-law, was in on the network. Irenus was born in Lyme, and his father, Dr. Cyrus Hamilton, was a prominent doctor. Irenus was a farmer who operated a sawmill and gristmill and served as a state senator. He inherited the house from his father, who died in 1826. A 1954 newspaper article in the Thetford Historical file records that fugitive slaves were hidden in the cellar of the Hamilton house.

Opposite, top: The Lyme Congregational Church minister lived in the parsonage south of Lyme Plain in the 1800s. The Reverend Erdix Tenny and his family were involved with the Lyme Underground Railroad network, and they lived in a brick house on this location that later burned. *Courtesy of Michelle Arnosky Sherburne.*

The Hamilton House sits across from the Lyme Common and was the home of Irenus Hamilton during the time when fugitive slaves were brought to Lyme and relayed through the village. *Courtesy of Michelle Arnosky Sherburne.*

It is the reminiscences of Calvin's son, Payson, that give a unique perspective of the network in action. In a 1906 *Boston Herald* news article, Lyme was touted as "famous all over New England as a station on the road to Canada." Calvin Fairfield was singled out as sheltering runaway slaves. Fairfield provided another family connection to Canaan; he married Sarah Sheldon Harris, the daughter of Canaan agent John Hough Harris. Harris and another son-in-law, James A. Furber, regularly received fugitives.

Samuel West Balch

Not in the mini-network but a comrade in the abolitionist cause was Lyme resident Samuel Balch. He was an active Underground Railroad agent. He served as treasurer of the Lyme Antislavery Society and also was responsible for the membership dues for the New Hampshire Abolition Society.

Balch was a famous teamster whose six-horse team and wagon was known as "Ship of the Mountains." He traveled to Boston, where the local merchandise was marketed, and stocked up on supplies for the townspeople.

Balch's teaming industry in Lyme is so beautifully described in an 1881 newspaper article:

> *Five or six tons was the average load for which seven or eight horses were required. Usually six horses and a good leader were found to work best. No reins were used as the horses were driven by word and whip, like oxen… The time occupied by the trip was usually 14 days, six in going, seven in returning and one in Boston. 21 trips were made each year…Mr. Balch used to always leave Lyme in the morning, make his first stop nine miles at Canaan, and the first stop for the night at Bullocks Hotel, Grafton, 17 miles from home. The second night was spent at Andover or Salisbury, and then the route would be on through Concord and Nashua to Boston.*

As well as being a teamster, Balch followed in his father's footsteps in the tanning business. He got into shoe manufacturing, producing leather goods and shoes. He installed the first steam engine north of Concord, New Hampshire.

Balch was active in the abolitionist movement not only with the Lyme and New Hampshire antislavery societies but also in promoting the abolitionist newspaper subscriptions. He regularly helped fugitive slaves on their journey

The Samuel Balch House was an Underground Railroad safe house in Lyme. The two Balch houses on the property are still standing and remain in the Balch family. *Courtesy of Michelle Arnosky Sherburne.*

north by hiding them in his house and then transporting them to the next safe house, usually the Bliss Tavern in Haverhill.

He lived north of the Lyme Village. There are two Balch houses on the property. The original house is on Route 10, and a smaller Cape is the second Balch house behind the roadside one. Both properties could have been used to hide fugitives and are still in the Balch family today.

The Balch family passed on stories of Balch's Underground Railroad efforts. When it was safe to send fugitives to the next place, Balch had his sons hide slaves in the hay wagon and take them north to Haverhill's Bliss Tavern. In a similar scenario of the other Lyme network, he utilized his boys, who would not be as apt to be suspected. Samuel's grandson Ralph Balch passed along this story of his grandparents hiding slaves from federal marshals:

> *A group of fugitive slaves arrived at Balch's home. There was urgency to hide them because the Balchs had received word that federal agents were in*

town. Samuel quickly hid the group but his wife separated one, petite elderly woman and hid her upstairs in bed with her children.

As expected there was pounding on the door, the authorities barged into the house, and accused Samuel of illegal conduct. Samuel was cool and collected. He allowed them to search the house. When they headed for the stairs, Mrs. Balch warned them not to wake the children. The agents opened the children's door and shone in the lantern. All they saw were children peacefully sleeping. Not finding any fugitives, the agents left. Safe and sound, tucked way under the covers, out of sight was the elderly woman. What a close call!

Samuel loaded his stowaways in his wagon and took them to Haverhill.

Dudley Ladd III and Dr. Jesse Merrill—Franklin

The *History of Salisbury* credited Dudley Ladd as an Underground Railroad agent, stating, "Mr. Ladd was a strong anti-slavery advocate and often secreted slaves on their way north to liberty, for which he was once arrested, but the case never came to trial." Ladd's participation is preserved as local tradition and not documented. It has been stated that Ladd received fugitives from a relative in Concord and sent them to Potter Place or to White River Junction, Vermont.

Franklin historian Elizabeth C. Jewell stated in her book *Franklin* that "lore has it that when the abolitionist family living here was raided in a search for runaway slaves, they sent a young daughter to bed, beneath which several slaves were hidden. The family told the searchers the girl was deathly ill with a very contagious disease. The ruse worked and the searchers left."

Ladd moved from his hometown in Concord, Massachusetts, to Salisbury (now known as Franklin). He built his home in 1823 and lived there with his first wife, Charlotte, and then his second wife, Amanda. Ladd manufactured lead pipe and set up shop at the old Eastman wire shop in Salisbury East Village. He was responsible for supplying pipe for the aqueduct construction in New Hampshire, Vermont and Maine. The Concord statehouse was built in 1818, and Ladd's handiwork can be seen in the tinsmith work on the dome. He built a number of homes in Franklin.

He was very active in community affairs and was a strong advocate for the temperance movement. He and his wife Amanda were among the people who helped establish the Congregational church.

Two other people who worked with the Ladds in the church efforts were Dr. Jesse and Sally Merrill. Dudley and Dr. Merrill also worked together on helping fugitive slaves. Merrill, a Peacham, Vermont native, was known as the leading physician in Franklin and the surrounding area for over twenty-five years.

In the *History of Salisbury*, it states that Merrill was a co-laborer with Ladd: "The fugitive slave, as he fled from bondage in our then boasted land of freedom had the sympathy, the encouragement and material aid of these gentlemen."

John Hough Harris, James Furber and Nathaniel Currier—Canaan

Canaan historian and president of the Canaan Historical Society Donna Zani-Dunkerton stated that there were three documented agents in Canaan: Nathaniel Currier, John Hough Harris and his son-in-law James Furber. There was a steady flow of fugitive slaves brought to Canaan as early as the 1830s because of the traffic coming north from Concord.

Zani-Dunkerton's great-great-grandfather Currier built a house on Canaan Street in 1814. Her grandparents lived in the Currier House on Canaan Street until 1968. She remembers the stories told in the family and also the passage for hiding slaves that Currier had constructed under the stairs. After the house was sold out of the family and renovations were done, the slave passage doesn't exist.

But Zani-Dunkerton knew it and described it. Upon entering the side door of the house, the entrance to the kitchen is on the left with a flight of stairs in front of you. The chimney was in the center of the house and ran up along the center staircase wall on the right side of the stairs. Once in the kitchen, Zani-Dunkerton would stand facing the center of the house, which was the staircase wall. On that wall was a concealed door that was built like Venetian blinds (you could not see in but could see out). The door opened to a hiding place built under the center staircase that had two benches against the wall. Slaves were hidden in there and then led up the center staircase to the attic. It would be possible to stay hidden on the second floor in the back of the house and possibly gain entry into the carriage house from the attic.

Her grandmother told her about President Calvin Coolidge's 1932 visit to Canaan and that the presidential entourage and town leaders congregated

On Canaan Street, the Nathaniel Currier House sheltered fugitive slaves when they arrived in Canaan. Nathaniel Currier was involved with the Noyes Academy. *Courtesy of Michelle Arnosky Sherburne.*

at the Currier House. The president was shown the slave passage, and someone in the group drew a picture of the slave passage on a napkin. For years that illustration was saved, but it was eventually lost.

Runaway slaves were brought to agents Furber and Harris, who lived on Prospect Hill Road, today on the grounds of the Cardigan Mountain School. It was a busy station on the Underground Railroad, receiving fugitives once a month, according to Furber's grandson Charles Lord. Harris and his son-in-law Furber shared the house and agent duties. Harris had aided fugitive slaves since 1830. Furber was responsible for transporting the slaves to the next station in Lyme.

Lord wrote to Wilbur Siebert in 1896, sharing that his grandfather "lived for several years in Canaan, where his house was one of the stations of the Underground Railway. His father-in-law, James [*sic*] Harris, who lived in the same house, had been engaged in helping fugitive slaves on toward Canada ever since 1830." Lord remembered an incident when he was a child visiting his grandfather in 1859. He saw a black man sitting behind a door in the house who told him he had been brought north from Concord, New Hampshire.

The Furber-Harris House was a safe house for fugitive slaves arriving in Canaan. It also housed black students attending Noyes Academy in 1835. The house was inhabited by John Hough Harris and his wife, his daughter and son-in-law James Furber. Both Harris and Furber were agents. *Courtesy of Donna Zani-Dunkerton private collection.*

Local historians record that upon arrival at the Furber-Harris House, the slaves were transferred to the barn for safety. Then Furber and the fugitives would travel on the Grafton Turnpike to Lyme, or if necessary, take another route to Hanover and Lyme.

In the 1830s, the short-lived Noyes Academy, located just south of the old North Congregational Church, had black teenagers enrolled. The George Kimball house, which was torn down years ago, and the Furber-Harris house were used to house the black students. Interestingly, Harris was also one of the incorporators of the Noyes Academy.

Dr. Timothy Tilton was instrumental in the Noyes Academy. He had moved to Canaan in 1813, becoming the town doctor. He also served as town magistrate and lawyer. He was a member and deacon of the Congregational church and member of the Canaan Musical Society. He helped form the Masonic society in town. Dr. Tilton was a unique character who was involved in good causes and highly regarded, but he was also known for excessive drinking and always being in debt. He was sent to Haverhill Jail for a debt charge once.

He died in 1836, and on his gravestone, he requested the following inscription: "The Slave's Friend." It is not documented if Tilton helped Furber, Harris and Currier transport or harbor fugitives, but one has to wonder. His role with the Noyes Academy was with free students, not fugitive slave students. Nevertheless, Tilton summed up his abolitionist personal mission in that inscription.

John Coe—Center Harbor

The son of a Congregational minister, John Coe was born in Durham, New Hampshire. Coe started his mercantile career in his brother's store in

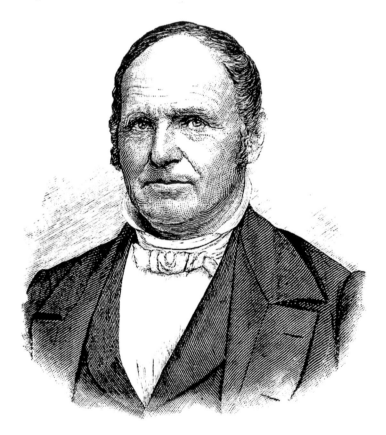

John Coe built the Coe Mansion in Center Harbor and was responsible for helping fugitive slaves through town. *Courtesy of Center Harbor Schoolhouse Museum.*

Newmarket. Eventually, he moved to Center Harbor in 1819 and bought a country store. He ordered merchandise from Portsmouth that was shipped up Lake Winnipesaukee to Center Harbor.

He married Lavinia Senter, whose father owned the Senter House. They bought it from her father, remodeled it and ran it as a hotel. They had six children and then built their own house, the Coe Mansion. Construction took three years and started in 1820.

The Coes donated the land on which the Congregational church was built in 1837.

They relocated to Durham, and John got into shipbuilding there. He was a staunch temperance man and had no tolerance for alcohol use. When John learned that the shipbuilders were drinking on the job, he ordered them to stop. The builders refused to work, so John found replacements for them.

The Coes then moved to Boston for four years, where John managed the Marlboro Hotel. He left his son Curtis to manage the Senter House, which was a hotel. But the Coes wanted to be in Center Harbor, and in 1850, they returned home.

John took over the Senter House, but the Coes used their creativity and resources to make interior and exterior improvements to their home, the Coe Mansion. Sparing no expense, they imported wallpaper from France that displayed full, elaborate murals of the Seven Wonders of the World. That wallpaper was renovated and can be seen in the twenty-first century.

John and Lavinia were well known and active in the community. They socialized with well-known abolitionists, and the New Hampshire poet John Greenleaf Whittier spent much time in Center Harbor writing. Whittier was close to Lavinia's family and John Coe. Coe Mansion visitors included three presidents (Franklin Pierce, Ulysses Grant and Grover Cleveland) and poets Lucy Larcum, Celia Thaxter and Whittier.

Other visitors at the Coe Mansion were fugitive slaves. The Coes were in the Underground Railroad network, known to be ready to move northward the runaways brought to them. Discreet deliveries were led into the ell at the back of the house to the kitchen. There was a secret passage in the Coe Mansion kitchen that led to a tunnel system to move the secret visitors through town below ground.

Years ago, there was an obscure square in the kitchen floor pattern, and only a few knew of its existence. Pulling up the square revealed narrow stairs that went down to the cellar. On the back cellar wall was a tunnel entrance and a tunnel that branched out in three directions. One tunnel destination was to the horse sheds. In the 1960s, Daniel Fleetham was the

Today it is Lavinia's Restaurant, but in the 1800s, it was known as the Coe Mansion, where dignitaries would stay in Center Harbor, New Hampshire. The owner, John Coe, helped fugitive slaves through town, and there is still a tunnel in the basement of the building. *Courtesy of Michelle Arnosky Sherburne.*

superintendent of grounds of the now-defunct Belknap College, which used the Coe Mansion for dorms. Fleetham found in the horse sheds, there was a large closet with a secret door. Inside were shelves with ample width for a person to sleep on, and in the back of the closet was another secret door. For years, the Coe Mansion tunnel entrance was cemented shut.

Connie Johnson, the secretary of the Center Harbor Historical Society, remembers what were known as the "slave tunnels" and seeing one at the Coe Mansion. In the 1960s and 1970s, the tunnel entrance had been opened. Johnson was ten years old and visited the Coe Mansion often. She was shown the slave tunnels by Fleetham and told, "Don't ever go down there—it's too dangerous."

At that time, Johnson said she could see that the tunnel passages went in three directions: left, straight and right. She thought it appeared that the tunnels went to these buildings back in the 1970s: the Garnet Inn, Nichols Store and out to the Coe Mansion barn.

The tunnel entrance pictured here is in the basement of Lavinia's Restaurant in Center Harbor. The building was an Underground Railroad safe house owned by John Coe in the 1800s, and the tunnel branched underground to three locations, allowing for slaves to move unseen beneath Center Harbor to the Coe barn or two other homes in town. *Courtesy of Michelle Arnosky Sherburne.*

During construction of the parking lots on Coe property, the tunnels collapsed. The only remnant left in the twenty-first century is the entrance in the Coe Mansion basement and a distance of possibly twenty feet of tunnel.

Nathaniel Peabody Rogers—Plymouth

We have learned about Nathaniel Peabody Rogers's major contributions to the abolitionist movement through his lectures, support and, most importantly, his newspaper, *Herald of Freedom*. He was a major abolitionist in New Hampshire, but in this chapter, the focus will be on the Rogers mansion in Plymouth, where Rogers hid fugitives traveling through the town. There is documentation that Rogers hid fugitives at both his Plymouth and Concord residences.

In the Lamson Library files at Plymouth University, Plymouth resident Manny Sterling's statement is in the Rogers files. Sterling said, "The Rogers mansion, his home in Plymouth, N.H. where the Silver Center for the Arts now stands is known to have been a 'safe house' on the Underground Railroad, having a hidden room in the attic and a trap door with a ladder leading to the basement."

A June 5, 1954 *Plymouth Record* article stated:

> *It is on record that about 30 years ago, a son and a daughter of Nathaniel P. Rogers—the son over 90 and the daughter in her 80s—called at the brick mansion here. They went from room to room, noting changes, and telling stories about "the old days," when they lived there. The man recalled that he could remember when he and his brothers would wake up in the morning—and find a Negro—lying on the floor—or huddled in a corner, head nodding between his knees!*

The article recounted the tour of the old mansion by the current college president, Dr. Harold Hyde, and his wife. The *Record* article stated:

> *Dr. Hyde is shown here, peering into the small closet which descendants of Nathaniel P. Rogers claim was used to hide negroes fleeing bondage from the south. He is shown holding a shelf, easily removable, and the false wall at the back is shown opening into the space beyond like a door. Other rooms on the north side include the old kitchen and what was originally a pantry…A second large hall leads from the beautiful staircase to the second floor which has large, airy chambers with plenty of closet room. In one of the southern chambers is the little closet which opens into a secret chamber under the roof, where fugitives from the South were hidden long before the Civil War days. It has two shelves which may be removed; and the sheathings at the back is actually a door which opens into the space under the roof. It was easy to hide*

fugitives here. It is generally believed that there was an underground tunnel for fugitives and the basement of the old house would seem to bear this out, although it has been denied.

William Lloyd Garrison's June 7, 1842 letter to Rogers, who was living in Concord at that time, mentions helping a fugitive slave and sending him northward to eventually be aided by Rogers and another Plymouth man, Denison Burnham:

At the time of our late New England Convention, a young colored lad came to one of our meetings, in the capacity of a runaway chattel; and as he was anxious to follow the North star even into Canada…His statement is as follows. On arriving at Concord in the stage, he saw you [Nathaniel Rogers], *from whom he received a note, (which I have now in my possession), to Denison R. Burnham, of Plymouth, and to Edmund Carleton, of Littleton, soliciting their friendly offices, &c…The next morning, he resumed his journey in the stage.*

A Plymouth resident wrote Wilbur Siebert in 1936 about Burnham being an antislavery man but didn't think he had helped slaves. Caroline W. Mudgett writes, "Soon after 1840, Denison S. Burnham became proprietor of the inn later known as the Pemigewasset House, and was somewhat in sympathy with the anti-slavery movement, but as my mother, born in 1830, was an intimate friend of the family and never mentioned any active interest on his part, I doubt any connection with the slave running." Garrison's letter proves he did help slaves.

Timothy Blaisdell—Haverhill

Haverhill is one of those towns that is mentioned in many Underground Railroad texts but has no person credited with helping the fugitives. But the townspeople, local historians and families in Haverhill know it was Timothy Blaisdell at the Bliss Tavern on Court Street. In Haverhill, the oral tradition of the Underground Railroad remains along with the physical evidence.

Fugitives were brought from Lyme Underground Railroad agents by wagon to Haverhill. It is recorded that Samuel Balch and his sons in Lyme delivered fugitives, and Calvin Fairfield also made trips to Blaisdell's tavern

The Bliss Tavern, owned by Betty Johnson Gray, was an Underground Railroad safe house operated by Timothy Blaisdell in the 1800s. *Courtesy of Michelle Arnosky Sherburne.*

with "shipments." The fugitives were sheltered in the home of Timothy K. Blaisdell, a prominent merchant who lived in the Bliss Tavern in the 1840s.

In the *History of the Town of Haverhill*, Blaisdell is referred to as "a pronounced Abolitionist." He was a member of the American Anti-Slavery Society. Mildred C. Paulsen, Blaisdell's granddaughter, wrote a letter to Siebert in 1935 about Underground Railroad activity. She reported that her grandfather was the only person in town who received and cared for fugitives:

> *I am very glad to tell you the very little I know about the underground railroad here in Haverhill. My grandfather, Timothy K. Blaisdell was, so far as I know, the only person in town who received and cared for the fugitives and sent them on to Littleton or some other town north of here—He, at that time lived in what was the Bliss Tavern, and which is still standing—…*
>
> *I imagine, from what my mother told me, that many of the slaves came to grandfather from Boston. Grandfather was a very earnest worker for the cause and he made the remark once that the proudest moment of his life was when he was "rotten egged" on Boston Common for making a speech on abolition.*

In the registry of New Hampshire's antislavery societies, Blaisdell was the Haverhill representative who registered ninety-five members from his town in July 1835. He attended the fourth annual meeting of the American Anti-Slavery Society in New York City in 1837. He served as one of eight vice-presidents at the First Annual Meeting of the New Hampshire Young Men's Anti-Slavery Society in August 1839.

The Bliss Tavern is on the corner of Court Street and the North Common in the center of Haverhill Corner. It was a busy stop on the western New Hampshire stagecoach routes. Katharine Blaisdell recorded in *Over the River and Through the Years* that there were seventy-five to two hundred passengers arriving via stagecoaches nightly in Haverhill.

Haverhill was also the location of the Grafton County Courthouse and Jail. The influx of lawyers, law enforcement authorities and court-connected visitors, as well as the prisoners, kept the traffic to Haverhill constant. All the legal and court records were housed at the courthouse.

The Bliss Tavern was not out of town in a secluded spot; it was next door to the courthouse. And being a tavern, it was never quiet there. Even among all that public traffic, Blaisdell was a steadfast believer in helping fugitives, though if caught, he would have ended up in the "gaol" next door.

Timothy Blaisdell had twin daughters, and one of them, Harriet Blaisdell Cram, shared accounts of seeing fugitives in the house when she was growing up. These were recorded in the *History of Haverhill* written in the late 1890s. Cram shared that one night Blaisdell brought a slave into the house around midnight. The next morning, Harriet and her twin entered a room to find him sleeping on a folding bed. They startled him and he jumped up, scaring them. Another time, Cram found a black man hiding in the closet.

The cellar has an opening in the wall that is the beginning of a tunnel that run under the common to the bank on the other side of Route 10, where the meadows lead down to the Connecticut River. A cellar alcove could have been used to hide slaves before smuggling them upstairs.

On the first floor, there is a closet with stairs that begin six feet from the floor and lead to the ceiling. Two of the ceiling boards are removable, creating an entrance into a second-floor pantry. In the pantry, there was a Dutch smoke oven used for curing meat and a dumbwaiter for a ballroom on the second floor. The pantry is built around the center chimney. On the right side of the chimney, the bricks are terraced and the space is six feet high. At the top of that section, there is a trapdoor that leads to the attic. Once in the attic space, the slaves were hidden in the large area around the chimney, as many as twelve at a time.

The Bliss Tavern, in Haverhill, New Hampshire, received fugitive slaves from agents in Lyme. This cellar entrance was how Bliss owner Timothy Blaisdell brought them into the house. *Courtesy of Michelle Arnosky Sherburne.*

After Haverhill, fugitives were sent to Littleton, New Hampshire, or crossed the river into Newbury, Vermont.

The financial Panic of 1837 hit Blaisdell hard, and his business failed in town. He left Haverhill and, by 1846, had relocated to Boston. He became a partner in a polishing brick manufacturing company; in 1848, he was part of Mt. Eagle Manufacturing and dabbled in different business ventures that didn't fare well.

He continued his involvement in the White Mountain IOOF Lodge, registered for the year 1854. Traces of his life in Boston are scarce, and he died in 1867 because his grave is registered in the Mount Auburn Cemetery in Cambridge, Massachusetts, for that year.

The Three Moseses of New Hampshire's Underground Railroad and Abolitionist Movement

In New Hampshire's Underground Railroad efforts and abolitionist movement, there were three men named Moses: Moses Sawyer of Weare, Moses Cartland of Lee and Moses Cheney of Peterborough and Ashland.

The name Moses is best known for the biblical Moses, the Hebrew child who was raised by an Egyptian princess and was responsible for guiding the Hebrew slaves out of Egyptian slavery to freedom. Moses led the exodus to Canaan, the Promised Land of the Israelites.

Slaves in the South knew the story well, and they drew strength and hope from the Bible stories. Their Promised Land was Canada, where no slavery existed. They prayed for their own "exodus" like Moses and the Israelites where thousands would journey out of slavery to the Promised Land. The exodus that actually happened was the thousands who ran away and were helped by Underground Railroad agents. They created their own exodus. The fugitive slave and famous Underground Railroad phenom Harriet Tubman was called the "Moses of her people."

Sawyer and Cartland are mentioned together in many references about Underground Railroad efforts in the state. An 1895 article in the *Granite State Monthly, A New Hampshire Magazine* stated, "The residence of Moses Sawyer, who established and managed the Weare woolen mills from 1831 to 1886, and Moses Cartland, both influential Friends—were stations of the 'Underground Railway.'" There was a large contingent of Quakers in the state, thus the reference to "Friends" in that quote.

Duane Shaffer in *Men of Granite: New Hampshire's Soldiers in the Civil War* wrote, "The homes of [Moses] Sawyer and Moses Cartland served as stations in the Underground Railroad. Moses Sawyer, a Quaker who with his friend Thomas Folsom ran a safehouse in Epping for runaway slaves made the acquaintance of Whittier."

Moses Sawyer—Weare

Sawyer was born in Henniker and raised as a Quaker. He learned the clothing and fulling trade in Henniker and Vermont before moving to Amesbury,

Moses Sawyer was a close friend of Frederick Douglass and Moses Cartland of Lee. Sawyer was an Underground Railroad agent in Weare, New Hampshire. *Courtesy of the* Granite Monthly, *November 1895, "Along the Piscataquog: A Sketch of Weare."*

Massachusetts. It was while he was training in Massachusetts that he met William Lloyd Garrison and poet John Greenleaf Whittier.

Sawyer's daughter Ellen Smith wrote to Underground Railroad researcher Wilbur Siebert in May 1935 and stated, "When my father was a young man he went to Amesbury to learn his trade of 'fuller' in the mills there; at that time Wm. Lloyd Garrison was editing a newspaper in Newburyport. The two met and a lifelong friendship resulted, also with Whittier."

There Sawyer worked for several years in the mill business before he was able to return to New Hampshire and start the Weare woolen mills. Weare was barely a town when he moved there, but the mills brought workers, families and the railroad, and the town grew.

Sawyer was steadfast in his religious beliefs and did not hold public office, though he was involved in his community. He did serve in the state legislature in the late 1880s. He was very active in the abolitionist movement and helped organize conventions in the state. He was close friends with Frederick Douglass, who would stay in the Sawyer home when he was in New Hampshire during his 1842 and 1844 lecturing tours. Smith wrote to Siebert that "Fred Douglass was there in the early days and never forgot my father." It was while at Sawyer's home that Douglass started one of his autobiographies.

In Sawyer's house, there were rooms in the cellar where the fugitives stayed. Smith shared with Siebert what she knew, even though she wasn't kept apprised of all her father's efforts. She wrote:

> *I can recall as a child Negroes as guests in our home which possibly might have been "underground" guests. My father was a Friend, Quaker and of course was opposed to slavery; I have wondered how many persons he helped to freedom, of course their work was done secretly at night, and by private conveyance. So near as I can judge from letters the "station" from which his guests came was in West Newbury at another "underground railway" station, it was near enuf to drive from there in one night; my father's friend in Concord was the president of the Concord-Montreal R.R.; how they communicated I do not know but in some way father knew when a freight train was to leave Concord, fourteen miles from our home, which was to go through without stopping; father would take his Negroes, after dark, in his own conveyance, and would meet this friend at some named spot and when the train was ready to start they would go to it, this friend would unfasten the car, the Negroes would climb in on top of the wheat, I*

guess, usually, the car was locked, and the seal put over it that it was full not to be opened until Montreal was reached, and father would get home again before day light.

…The work in New England was quietly done, strong feelings about it…Father used to tell us of some of the experiences that would be reported, but not details of the work.

Moses Cartland—Lee

In Lee, Moses Cartland was a staunch abolitionist and founder of Clinton Grove Academy. He helped numerous slaves on their journeys north and was close friends with Moses Sawyer, William Lloyd Garrison and his cousin John Greenleaf Whittier. *Courtesy of the* Granite Monthly, *November 1895, "Along the Piscataquog: A Sketch of Weare."*

The second Moses in the duo was Moses Cartland, who was born in Lee. As with Sawyer, he was raised a Quaker and grew up in Weare. His focus was education, and he attended school in Providence, Rhode Island, and eventually began student teaching there. He returned to his hometown area after a couple years.

In 1834, Cartland opened the Clinton Grove Academy, which was a successful school. For fourteen years he served as principal.

Cartland also was second cousin of the famous poet John Greenleaf Whittier. Whittier occasionally aided fugitives himself, as was the case with fugitive slave Oliver Cromwell Gilbert.

Jody Fernald, University of New Hampshire acquisitions librarian at Dimond Library, conducted extensive research on the life of Gilbert and his memoir. Gilbert was a fugitive slave from Maryland who originally settled in Boston and worked with major abolitionists like

Garrison, Wendell Phillips and William Nell. But when the Fugitive Slave Act of 1850 alarmed fugitive slaves and they migrated out of the country, Gilbert was aided by the Boston Vigilance Committee in April 1851. He was taken to New Hampshire through Whittier's connections to the home of Moses Cartland. Gilbert stayed for two years with the Cartlands. He later returned to Boston and continued his work as an abolitionist lecturer before moving to New York.

Stephen Millett Thompson (Assisted Moses Cartland)

In the Siebert New Hampshire collection, there is a letter from Stephen Millett Thompson, who grew up in the Lee area and wrote of his assistance with fugitive slaves. Thompson, who served in the Thirteenth Regiment of New Hampshire Infantry, was the author of *Three Years and a Day: 1862–1865*, a highly regarded regimental Civil War history. Thompson's memoir drew from diaries, letters and conversations with fellow veterans, and in the twenty-first century, it has been singled out from the hundreds of Civil War regimental histories for its unique firsthand perspective of the war experience.

In Thompson's letter to Siebert about fugitive slaves in New Hampshire, he refers to the "residence of the late Jonathan Cartland," Moses Cartland's father. Instead of mentioning Moses directly, Thompson used his father's name. It has been said that helping fugitives was a Cartland family affair, but it also is a common feature in these late nineteenth-century letters that care was used to not share names of agents directly.

Thompson shared that when he was a boy, he helped as a guide to take fugitives through the wooded terrain to get to the next safe house. He explained that he was told to wait at a specific location where he would be met by a fugitive, and it was his job to get that person safely to the next place. He wrote:

> *The route of the Underground Railroad which I knew in and near Lee, N.H., was from the residence of the late Jonathan Cartland, on the western side of that town, considered as a Station, or in the terms of those days a stopping place,—to the northwestward into Nottingham; about six miles in all, though once or twice I struck across there with fugitives as far as to the Portsmouth and Concord Turnpike—a long tramp…My house was at Little River Mills, half a mile north of theirs, the Cartlands.*

The method of operating the Railroad was so little known to me, as my service was only that of a guide, or Conductor, and all matters were kept so excessively secret, that I could not now safely attempt a description of it.

I know that runaway slaves were rarely mentioned as such; but instead were indicated under some term common to farming operations. For an instance:—At tea time John said to his family—"I am going over to cousin Samuel's this evening, to see if I can have his oxen a little while." And John sometimes staid until rather late at cousin Samuel's. The "oxen" would be found buried deep under hay in Samuel's barn—and John's poor team next morning would be likely to appear as if it had galloped through seven cities— none of them having a street cleaning department. The truth was a couple of runaway slaves had spanned ten or fifteen miles toward Canada by that one team; and doubtless two or three other teams had each helped them on before daylight came again. I heard of fugitives being held for a week in hiding, waiting for the skies to clear,—while the clear skies actually waited for was the blackest night that might come along. The number of fugitives who passed over the Lee route and near was surely respectable.

Thompson shared several stories of his adventures in the letter. What is interesting is that he never capitalized on being part of helping fugitive slaves. He never wrote a book on his experiences. It was only in response to direct questions that Thompson shared information. As with most Underground Railroad efforts, the people kept the work quiet, even years after the Civil War.

Moses Cheney—Holderness and Peterborough

Moses and Abigail Cheney were well-known abolitionists who had three famous sons: Oren, president of Bates College; Elias, the American consul to Curacao; and Person, a New Hampshire governor and then minister to Switzerland.

The Cheneys lived in Holderness originally, moved to Peterborough for ten years and then returned to Holderness. Their Underground Railroad efforts were in both towns, but they are more popularly known for the Peterborough connections.

Moses was in paper manufacturing with his cousin at Holderness, and their paper mill was one of the first built in New Hampshire. Their paper was sold as far away as Portland, Boston and New York. He held important offices in church and state and served in the state legislature.

Abigail was described as a woman of energy and strong character. She was an abolitionist but also campaigned for the temperance movement well before it was in full force.

As with the Sawyers, Frederick Douglass was friends with the Cheneys. Their son Oren wrote to Siebert in 1896, "My father was a pronounced anti-slavery man & his home in Holderness (now Ashland) N.H. was the home of Fred Douglass when he was in the state. During ten years he lived at Peterboro & Fred Douglas came there."

The abolitionist connections were strong and interwoven. The Cheneys knew Nathaniel Peabody Rogers, the editor of the *Herald of Freedom*, through his work in one of the first Sunday schools in New Hampshire in Holderness. Rogers served as Oren's first Sunday school teacher.

The Cheneys' daughter, Sarah Abbott, also corresponded with Siebert in 1896 about her father helping fugitives: "My father Dea[con] Moses Cheney then of Peterboro, N.H...entertained 'runaways' and forwarded them to the brothers James and Moses Woods of Hancock, N.H."

Leonard Chase—Milford

Milford was known as an antislavery town, and abolitionists knew they were welcome in town. It was the town that produced the famous Hutchinson Family Singers, who supported the abolitionist cause through their music. Frederick Douglass knew the family well and possibly stayed at their house on his visits to Milford.

In 1843, an antislavery convention was held in Milford and attended by famous abolitionists Garrison, Phillips, Pillsbury, Rogers, Remond, Abby Kelley Foster, Stephen Foster and Douglass.

In this town, fugitive slaves were welcomed as well—into the home of Leonard Chase.

Milford historian George Ramsdell wrote in the Milford town history that "the chief 'underground' manager here in Milford was Leonard Chase. With him were his brother, Abel Chase, John Mills, the members of the famous Hutchinson family singers, whose home [was] in town, and X.E. Mills. I have always understood that the fugitives who came this way came to Boston on ships and went north into Canada via the Connecticut River. Leonard Chase, and his business partner, Daniel Putnam, built two houses on what we call 'Hay Hills' in Milford Village. They were connected by a long shed."

Chase was born in Millbury, Massachusetts. He married a Milford girl, Mary Dickey, and moved to Milford and built his house in 1834.

He was a Garrisonian abolitionist, served as vice-president of the New Hampshire Antislavery Society and was a subscriber to the *Liberator*. Ramsdell wrote that Chase "was ready to maintain the principles of immediate emancipation of the slave when it was unpopular and almost dangerous to do so."

In 1843, Chase became partners in a furniture manufacturing company that helped the town grow.

Chase represented the town in the legislature in 1850 and 1851. He was a member of the state senate for two years and a member of the constitutional convention in 1852. Ramsdell recorded a story from Chase's daughter, Hannah Chase, that "soon after the rendition of Anthony Burns, one stormy night, word came to the house that the United States officers were on the track of a fugitive who was then harbored in the family. It was a time of intense anxiety to this household. Mr. Chase, thinking that the fugitive might be safer outside the village, harnessed his horse and carried the man to Luther Melendy's farmhouse in Amherst. Mr. Chase's House was one of the stations of the underground railroad."

The Melendys—Amherst

Luther and Lucinda Melendy were known in abolitionist circles as strong supporters of the cause. They opened their home to abolitionist lecturers like Garrison, Pillsbury and Douglass and worked diligently to further the cause in New Hampshire and New England.

Marion La Mere of Andover, New Hampshire, wrote Siebert on March 12, 1935, and quoted the *History of Amherst NH*:

> *Capt. Luther Melendy (of a line from Reading, Mass.) born June 2, 1793; m. Lucinda Kenney of Merrimack, May 31, 1825. They settled on a farm on Chestnut Hill cleared by his father, Thomas Melendy. For many years he was an active member of the Congregational Church. He was one of the first to engage in the anti-slavery movement, which he advocated and defended against the most determined opposition and lived to see crowned with success.*

Hannah Chase—the daughter of Leonard Chase, who was an Underground Railroad agent in Milford—told the story of a fugitive slave who arrived at the Chase home. But he was being pursued, and Chase thought it safer to move the fugitive to the Melendys' home in Amherst.

Chase knew the Melendys would be willing to help. The story on record from an eyewitness makes it plausible evidence. How many times the Melendys came to the aid of Chase and fugitive guests is unknown. But these statements, taken at face value, tell us that Luther and Lucinda Melendy's home on Chestnut Hill in Amherst was a stop on the Underground Railroad.

Luther and Lucida Melendy both died in the year 1883, and the inscription on their gravestone at the town cemetery in Amherst shares their devotion to the abolitionist cause: "The Slaves friend and the Colored Peoples benefactor."

OTHER NEW HAMPSHIRE SAFE HOUSES

Many houses in the North are said to have been on the Underground Railroad, but that is not always the case. The following are some possible safe houses that, through local tradition, have been connected to people living there who helped fugitive slaves.

Merrimack

Blanchard-Bowers House, one of the office buildings of Thomas More College, by local tradition, was used as a safe house. According to the *History of Merrimack, Vol. I,* one of the first-floor rooms of the main house has a trapdoor gaining entrance to a stone-lined tunnel that leads to a large room. There is also a three-foot-high tunnel in the cellar.

Portsmouth

South Church, at 292 State Street, was a sanctuary for runaway slaves in the years prior to the Civil War. The women of the church helped fugitives through the city using the church as the safe house. After the Civil War, the South Church Unitarian Women's Group operated schools for newly freed black Americans in the South.

The South Church on State Street in Portsmouth was said to have a women's group who helped hide fugitive slaves. *Courtesy of Michelle Arnosky Sherburne.*

Sandwich

The Durgin Bridge crosses the Cold River north of NH Route 113. Built in 1869, the bridge was named for James Holmes Durgin, owner of a nearby mill. The site has a distinguished history, having been part of the Underground Railroad prior to the construction of this particular bridge. There may be other houses in town that were used as safe houses. Sandwich had a large Quaker population that helped in the abolitionist cause.

Exeter

Marshall Snow wrote to Siebert about his father, Solomon P. Snow of Exeter, helping fugitive slaves. In his April 25, 1896 letter, Marshall wrote:

> *I think Fugitives came to Exeter from Newburyport, Mass., probably reaching there in vessels. I do not know anything definite about my father's connection with the Cause. He was an ardent lover of freedom for the negro and I heard him say when the Fugitive Slave Bill was passed, "I may have to go to jail, but I will disobey that law every time I have a chance." Until Emancipation came, I never heard him offer a prayer, in church, prayer-meeting or family devotion, without praying that the slave might be freed.*

Lyme

The Beal Tavern on Dorchester Road had a tunnel from the house cellar to the barn cellar. The house was built by James Beal in the mid-1780s, but it probably was a son, Selah Beal, who aided fugitive slaves.

Just south of Lyme Plain, Calvin Fairfield's house was on the Underground Railroad network in Lyme. *Courtesy of Michelle Arnosky Sherburne.*

The house is gone, but stories of where fugitives were hidden at the Samuel Claflin house remains. The Claflin house was on Bear Hill on Tyler Road. Refugees were delivered past the corner of the house to the large step in front of the south door of the house. There, they found a small hallway facing a closet. A panel in the back of the closet opened to the hiding place around the large center chimney.

Two other Lyme locations—the Warren Tavern at the corner of Shoestrap Road, south of Lyme Village, and the Dimick house on River Road—have been noted as safe houses.

More Safe Houses in New Hampshire

- Inn at Crotched Mountain, 534 Mountain Road, Francestown
- Dr. James Batcheller home, on Route 124, Jaffrey Road, Marlborough
- The Jack-O-Lantern Inn in Franconia has a hidden chamber behind the fireplace used for hiding slaves.
- Ballard B&B House, Parade Road, Meredith. In 2015, Mary Lamprey Bare shared that her ninety-year-old father said the local tradition was that this was an Underground Railroad safe house.
- Captain Asa Brewer House, now part of Franklin Pierce College, Rindge
- Kimball Tavern and Richard Diehl home on Dudley Hill Road, Pembroke
- Young-Cobleigh Tavern, Route 302, Lisbon
- Claremont, just north of West Claremont in the ravine called "the Tory Hole." When renovations to the building near that ravine were done in the early 2000s, a trapdoor was found in the basement by the construction crew. On the trapdoor were names carved all over, supposedly by fugitive slaves who had been hidden in the Tory Hole. Unfortunately, the construction foreman had the door destroyed so the project could be completed and not interrupted by state historical preservation attempts.
- The Latchstring home of Thomas Folsom in Epping, who worked with Moses Sawyer of Weare, aiding fugitive slaves
- Reverend Humphrey Moore Home, Elm Street, Milford. There was once an underground passageway leading from the cellar toward the river. Tradition is that it was an Underground Railroad station.

Reverend Moore, a strong abolitionist, served in the House of Representatives in 1840 and the state senate in 1841; in both places, he "gave stirring orations against slavery."

Chapter 16
ONA JUDGE STAINES

President George Washington's Pursuit and Ona's Success

Ona Judge's story is a testament to a woman's strength and determination to be free. It shows how strong the Underground Railroad's mission was to keep Ona safe even with a formidable foe like the president of the country. Sadly, it also shows the ignorant, prejudicial mindset of white Americans and their belief that their slaves were incapable of thought and desire for freedom.

Ona was born at the Mount Vernon estate in Virginia, owned by Martha Custis Washington and George Washington before he was president. Ona was the daughter of a white tailor and a slave seamstress who was one of 285 slaves originally owned by Martha's first husband, Daniel Custis. She was born in 1774. George had married Martha and taken on her Custis children and slaves.

At about ten years old, Ona moved to the Mansion House at Mount Vernon as a playmate for Martha's granddaughter Nelly Custis. Ona's domestic tasks included weaving cloth, churning butter, making soap, laundry and food preparation. At an early age, she was a skilled seamstress. She was promoted to Martha's personal attendant. She had house privileges, sleeping at the big house and not in slave quarters.

In 1789, George Washington was elected president. He supported the slavery institution established in the South, and he himself owned more than three hundred slaves in his lifetime. He needed slave labor to maintain his wealth and lifestyle.

At age sixteen, in 1789, Ona was one of seven slaves who traveled as the presidential household entourage when the Washingtons moved to New York City, where the presidential household was located. Then, in 1790, the national capital was transferred to Philadelphia. The Washingtons established the President's House (where today stands the Independence National Historical Park) with fifteen white indentured servants, nine slaves and several secretaries.

Because Pennsylvania had begun gradual abolition of slavery in 1780, the law stated that those born after the law took effect could be freed upon reaching age twenty-eight. It also stated that slaves who were brought to the state were considered free after six months' residence. The president created a loophole to avoid losing his slaves to Pennsylvania freedom. The Washingtons rotated their slaves between Mount Vernon and Philadelphia within the six-month window to avoid any legally becoming free while working at the Philadelphia location.

There were approximately two thousand free blacks living in Philadelphia, and a large number lived only two blocks from the Washington house. Ona may have encountered free blacks when she took the grandchildren on outings.

In 1796, Ona learned of Martha's intentions to give her as a wedding present to her granddaughter Eliza Custis. Ona made the conscious decision that she refused to remain a slave.

On May 21, 1796, while the Washingtons were preparing for a return trip to Mount Vernon, Ona packed her few items. She slipped out during dinner and hid with friends until a boat with a willing captain allowed her on board. She sailed north and ended up in Portsmouth, New Hampshire.

It was an embarrassment for the Washingtons that one of their slaves was missing. They assumed that she had been seduced and lured to run away. George and Martha were unable to fathom that a slave would want to escape their care. She had to have been lured away by a lover or a freedom seeker.

When they realized she was missing, the Washingtons published an ad in the *Pennsylvania Gazette* on May 24, 1796:

Advertisement.
Absconded from the houshold of the President of the United States, ONEY JUDGE, a light mulatto girl, much freckled, with very black eyes and bushy black hair, she is of middle stature, slender, and delicately formed, about 20 years of age. She has many changes of good clothes of all sorts, but they are not sufficiently recollected to be described—As there was suspicion of her

going off, nor [?] provocation to do so, it is not easy to conjecture whither she has gone, or as fully, what her design is; but as she may attempt to escape by water, all matteres of vessels are cautioned against admitting her into them, although it is probable she will attempt to pass for a free woman, and has, it is said; where-withal to pay her passage. Ten dollars will be paid to any person who will Bring her home, if taken in the city, or on board any vessel in the harbor;—and a reasonable additional sum if apprehended at, and brought from a greater distance, and in proportion to the distance.
FREDERICK KITT, Steward May 23

Ona's friends found a ship named the *Nancy* that would take her to Portsmouth. Captain John Bowles was at the helm of the *Nancy* and made trips to New Hampshire once a month. He and a Maine partner ran a freight business transporting harnesses, bridles, saddles and other leather products to New Hampshire. Ona stepped off the ship to begin her new life.

It didn't take long for someone in Portsmouth to recognize her. She was spotted by Elizabeth Langdon, the daughter of Senator John Langdon (who later would serve as governor) and a friend of Martha's granddaughter Nelly Custis. Senator Langdon's wife and daughter sent word of their discovery of the fugitive Ona Judge to the Washingtons. Ironically, Senator John Langdon owned slaves but politically was an abolitionist, so he had freed his house slaves and then hired them as paid employees. With the Ona Judge situation, Langdon was caught in the middle as a senator working under the owner in question. Also, he feared the Portsmouth public would be angry if he played a role in returning a fugitive slave.

After the Washingtons were notified of Ona's location, Washington contacted Joseph Whipple, Portsmouth's collector of customs (and also the brother of Declaration of Independence signer William Whipple and a slave owner himself). Whipple received the following instructions from Washington:

Joseph Whipple Letter in reply to President Washington's request, via staff Wolcott, dated Sept. 10, 1796
On the 10th Ultimo in answer to your letter of the 1st I advised you of the President's servant's being in this town.—Having discovered her place of residence, I engaged a passage for her in a Vessel preparing to sail for Philadelphia avoiding to give alarm by calling on her until the Vessel was ready,—I then caused her to be sent for as if to be employed in my family—After a cautious examination it appeared to me that she had not been decoyed away as had been apprehended, but that a thirst for compleat freedom which

This was the home of Governor John Langdon, who was involved in the Ona Judge story when he was a senator. Ona Judge, a fugitive slave from President George Washington's household, thought she was safe in Portsmouth until she was spotted by then Senator John Langdon's daughter Elizabeth, who knew her from visits to the Washingtons' home. Though President Washington pursued Judge, Langdon tried to stay out of the picture. He had previously owned slaves but gave them their freedom and provided paying jobs for them. Langdon later became governor of New Hampshire.

she was informed would take place on her arrival here or [at] Boston had been her only motive for absconding.—It gave me much satisfaction to find that when uninfluenced by fear she expressed great affection & reverence for her Master & Mistress, and without hesitation declared her willingness to return & to serve with fidelity during the lives of the President & his Lady if she could be freed on their decease, should she outlive them; but that she should rather suffer death than return to Slavery & [be] liable to be sold or given to any other persons.—Finding this to be her disposition & conceiving it would be a pleasing circumstance to both the President & his lady should she go back without compulsion, I prevailed on her to confide in my obtaining for her the freedom she so earnestly wished for—She made preparation with cheerfulness to go on board the Vessel which was to have sailed in a few hours and of her own accord proposed concealing her intention of returning from her acquaintance lest they should discourage her from her purpose.—I have recited this detail to show the girl's good disposition when expressing her uncontrolled sentiments and acting without bad advisers—I am extremely sorry to add, as

I conceive the girl is a valuable Servant to her Mistress, that the Vessel being detained by a contrary wind, in the course of the next day her intentions were discovered by her acquaintance who dissuaded her from returning and the vessel sailed without her.—

...In the present case if the President's servant continues inflexible & will not return voluntarily, which at present there is no prospect of, I conceive it would be the legal & most effectual mode of proceeding that a direction should come from an Officer of the President's Household to the Attorney of the United States in New Hampshire & that he adopt such measures for returning her to her master as are authorized by the Constitution of the United States,—and I shall be happy to facilitate the business to the utmost of my power in obedience.

Ona was confronted by Washington's aides to return to Mount Vernon free of punishment, but she refused. The Washingtons were offended by her unwillingness to return.

Nov. 28, 1796, President Washington's reply to Joseph Whipple
I regret that the attempt you made to restore the Girl (Oney Judge as she called herself while with us, and who, without the least provocation absconded from her Mistress) should have been attended with so little Success. To enter into such a compromise with her, as she suggested to you, is totally inadmissable, for reasons that must strike at first view: for however well disposed I might be to a gradual abolition, or even to an entire emancipation of that description of People (if the latter was in itself practicable at this moment) it would neither be politic or just to reward unfaithfulness with a premature preference; and thereby discontent before hand the minds of all her fellow-servants who by their steady attachments are far more deserving than herself of favor.

...For whatever she may have asserted to the contrary, there is no doubt in this family of her being seduced, and enticed off by a Frenchman, who was either really, or pretendedly deranged, and under that guise, used to frequent the family; and has never been seen here since [the] girl decamped. We have indeed, lately been informed thro' other channels that she went to Portsmouth with a Frenchman, who getting tired of her, as is presumed, left her; and that she had betaken herself to the needle, the use of which she well understood, for a livelihood.

If she will return to her former service without obliging me to use compulsory means to effect it her late conduct will be forgiven by her

Mistress, and she will meet with the same treatment from me that all the rest of her family (which is a very numerous one) shall receive. If she will not you would oblige me, by resorting to such measures as are proper to put her on board a Vessel bound either to Alexandria or the Federal City. Directed in either case, to my Manager at Mount Vernon; by the door of which the Vessel must pass, or to the care of Mr. [Tobias] Lear [Washington's secretary] at the last mentioned place, if the Vessel should not stop before it arrives at that Port.

I do not mean however, by this request, that such violent measures should be used as would excite a mob or riot, which might be the case if she has adherents, or even uneasy Sensations in the Minds of well disposed Citizens; rather than either of these should happen I would forego her Services altogether, and the example also which is of infinite[ly] more importance.

Joseph Whipple had the unfortunate duty to write the president admitting that he had not been successful in getting Ona onto a ship and back to her owners. The saga quieted down to a simmer, and Ona continued with her life.

In Greenland's town records, there is a document dated January 8, 1797, that states: "This may Certify that Mr. John Staines and Miss Oney Judge was Published in this Town." Their marriage was announced in the *Gazette*.

In the Greenland records, John "Jack" Staines and Oney Judge were married in Portsmouth. Jack Staines was a black sailor, and they settled in Portsmouth. In 1798, Ona and Jack had their first child.

After Washington left the presidency, he renewed efforts to retrieve Ona by sending his nephew to New Hampshire to find her. Senator Langdon was notified of this mission and redeemed himself by having a servant sent to warn Ona. She took her child and hired a wagon that took her to the small neighboring town of Greenland. Staines was at sea at the time. She hid with the John Jacks family, a free black family living in Greenland. She was safe there until the nephew left Portsmouth.

The Staineses had three children and were married only seven years before Jack died in 1803. Ona was forced to move to Greenland because she couldn't support the children alone. She lived with the Jacks family, but even together, work was scarce for blacks in the area. Ona had to give up her girls to be indentured servants, and her son became a sailor.

Ona learned how to read and write. She became a Christian and lived in Greenland the rest of her life. When asked if she was not sorry she left Washington, as she had labored so much harder since than before, her reply

(as quoted in the *Granite Freeman* of May 22, 1845) was, "No, I am free, and have, I trust been made a child of God by the means."

Technically, Ona was never freed due to the legal provision that one-third of the original Custis estate, including the slaves, could not be freed and were considered part of the Custis descendants' estate. Even after George and Martha died, their slaves were not freed.

A year before Ona died, she was interviewed by the Reverend Benjamin Chase for an article in the *Liberator* on January 1, 1847. He wrote:

> *I have recently made a visit to one of Gen. Washington's, or rather Mrs. Washington's slaves...She now resides with a colored woman by the name of Nancy Jack...at what is called the Bay side in Greenland, in New-Hampshire, and is maintained as a pauper by the county of Rockingham.*
>
> *She says that she was a chambermaid for Mrs. Washington; that she was a large girl at the time of the revolutionary war; that when Washington was elected President, she was taken to Philadelphia, and that, although well enough used as to work and living, she did not want to be a slave always, and she supposed if she went back to Virginia, she would never have a chance of escape.*
>
> *She took a passage in a vessel to Portsmouth, N.H. and there married a man by the name of Staines, and had three children, who, with her husband, are all dead. After she was married, and had one child, while her husband was gone to sea, Gen. Washington sent on a man by the name of Bassett* [Burwell Bassett Jr., Washington's nephew], *to prevail on her to go back. He saw her, and used all the persuasion he could, but she utterly refused to go with him. He returned, and then came again, with orders to take her by force, and carry her back. He put up with the late Gov.* [John] *Langdon, and made known his business, and the Governor gave her notice that she must leave Portsmouth that night, or she would be carried back. She went to a stable, and hired a boy, with a horse and carriage, to carry her to Mr. Jack's* [John Jacks, a free black], *at Greenland, where she now resides, a distance of eight miles, and remained there until her husband returned from sea, and Bassett did not find her.*
>
> *She says that she never received the least mental or moral instruction, of any kind, while she remained in Washington's family. But, after she came to Portsmouth, she learned to read; and when Elias Smith first preached in Portsmouth, she professes to have been converted to Christianity.*
>
> *She, and the woman with whom she lives, (who is nearly of her age,) appear to be, and have the reputation of being imbued with the real*

spirit of Christianity. She says that the stories told of Washington's piety and prayers, so far as she ever saw or heard while she was his slave, have no foundation. Card-playing and wine-drinking were the business at his parties, and he had more of such company Sundays than on any other day. I do not mention this as showing, in my estimation, his anti-Christian character, so much as the bare fact of being a slaveholder, and not a hundredth part so much as trying to kidnap this woman; but, in the minds of the community, it will weigh infinitely more.

This woman is yet a slave. If Washington could have got her and her child, they were constitutionally his; and if Mrs. Washington's heirs were now to claim her, and take her before Judge Woodbury, and prove their title, he would be bound, upon his oath, to deliver her up to them. Again— Langdon was guilty of a moral violation of the Constitution, in giving this woman notice of the agent being after her. It was frustrating the design, the intent of the Constitution, and he was equally guilty, morally, as those who would overthrow it.

Ona outlived both Washingtons and, sadly, outlived her children as well. She died in 1848 at age seventy-five.

In the twenty-first century, Ona's legacy was honored on February 25, 2008. Philadelphia celebrated the 160th anniversary of Ona's death with the first Oney Judge Day at the President's House site. On May 21, 2010, Oney Judge Freedom Day was celebrated, 214 years after she escaped slavery, at the same site in Philadelphia. In December 2010, Ona and the slaves who served at the President's House in Philadelphia were honored with a celebration.

Chapter 17
STORIES OF FUGITIVE SLAVES IN NEW HAMPSHIRE

Fugitive Slave Speaks at Dartmouth College

In the Rauner Special Collections at Dartmouth College, there is a letter written by Lemuel C. Spofford while in Hanover, New Hampshire, to William Bird of Gilmanton, New Hampshire, dated October 18, 1839. Spofford describes a fugitive slave's arrival in Hanover and local abolitionists who arranged for him to speak at the college chapel:

> *There was a pitiful object passed through this place a fortnight since. A poor runaway slave who had thrown off his shackles of slavery and was making his way through a land of freedom to a land of freedom. At the request of the good Abolitionists he went into the Chapel and told his pitiful tale in the presence of 400 or about that.*
>
> *He carried the marks of slavery which were arguments that could not be denied one was a very crooken [sic] leg which had been brocken [sic] by his mistress while she was in a rage at him. His master he said was a good he never whiped but once he said with 110 lashes because he forgot to tie the horses.*
>
> *"A good master" I should think. He was carried from here to Canida [sic] by the friends of the poor slave but came near being taken he went into a tavern where he saw two men whom he saw in Alabama but he is now free."*

Jack Ware of Hancock

A former slave named Jack Ware lived in Hancock, New Hampshire, and he told stories of how he had been kidnapped in Africa. *The History of Hancock, N.H. 1764–1889* recorded that "when he was a little boy a white man came along in a fine buggy and broke a cake in two; gave him one-half, and his brother the other; then he picked them up and carried them off just like a hawk would a hen." It is unclear when Ware arrived in Hancock. He was adored by his neighbors and lived to be one hundred. His gravestone was paid for by donations from the Hancock community.

Remembrance about a Slave

In E.J. Prescott's letter to Wilbur Siebert, dated April 16, 1942, he wrote about a slave named Robert Brown:

> *In my early boyhood there lived in an old shoe shop of rather larger proportions than the average, a negro by the name of Robert Brown together with his wife. Something like 20 years before he came there, he had come through as a slave on one hot August day, and had asked for work. Not a word was said about slavery, or about his running away, or about where he was going. He was put to work and together with the rest of the family, came in to supper. During the supper period, he looked across at my Grandmother and said, "Fine dress you have on, Mum." That was all that was ever said, and the following morning he was given the most explicit directions to go down through Durham on up to Epsom where he would be cared for.*

An Underground Railroad Guide

Stephen Millett Thompson of Lee served as a guide in connection to the Cartland safe house. In a letter to Wilbur Siebert, he shared a story of three fugitives he guided:

> *Another party consisted of a youngish man and two stalwart workers, both older than he, and far braver too. These had sharp knives and were very*

To be Sold at Public Vendue,

At the Houfe of Mr. James Stoodly, Innholder in
Portfmouth, on Wednefday the feventh Day of July
current, at Six of the Clock Afternoon,

Three Negro Men and a Boy :

The Conditions of Sale will be in Cafh, or good
Merchantable Boards. Portfmouth, July 1, 1762.

TO BE SOLD at Public Vendue,

On Tuefday the 22d of April Inftant, at
Two o'Clock Afternoon, at the Houfe
where the late Mr. *Thomas Beck* lived, in
the road leading to Rye, near Mr. *John
Langdon's* ; ------

ONE yoke of OXEN, feveral

Steers ; Cows ; Sheep ; I good Horfe ;
feveral Calves ; with fundry other Things,
Wearing Apparel, &c. A L S O,

A likely Negro GIRL.

TO BE SOLD

(Cheap for Cafh or good Lumber)

By William Pearne,

At his Store near the Hon. Mark Hunking
Wentworth's, *Efq; – Good*

COTTON WOOL, by the
bag or fmaller Quantity – Good Mof-
covado Sugar by the Hogfhead or fmaller
Quantity–Choice good old Rum – Good
Lignumvitae by the tun or hundred weight;
together with feveral forts of Englifh Goods.
– Alfo one NEGRO MAN about Twenty Years
of Age.

Advertisements for slaves, like these run on July 2, 1762, and two on April 3, 1767, were published in the *New Hampshire Gazette. Facsimiles created by Michelle Arnosky Sherburne.*

black. They went along rapidly all the way, and were aiming for a shallow place where they could wade across the river readily,—it was then a mill-pond and in places quite deep—and the negroes always complained of the coldness of the northern streams of water,—when they heard the report of a shot-gun. Upon this they asked a quick question or two about the course took off every stitch of their clothing, waded the stream—the water about four feet deep,—dressed again on the farther bank, rushed into the bush, and were gone.

Following is another story that Thompson shared: "There was one party of four men together, whom I directed along that route and pretty deep into Nottingham. One of these had an old shot gun, the other three had stout clubs, and each had an ordinary table knife (case-knife) sharpened to a brier edge. They were jolly fellows, and felt equal to anything that might oppose them."

Sent to Milford for Safety

Marion La Mere of Andover, New Hampshire, wrote to Siebert on March 12, 1935, that she had a newspaper article of a runaway slave who was working in a Boston restaurant. The slave's owner had learned that he was in Boston, and when the restaurant owner found out, he sent the fugitive to his brother, Xenophon E. Mills at Milford. As the story goes, a group of Milford residents and some Boston friends of the hotel owner pitched in to buy the slave from the owner and then granted his freedom.

The site of the first newspaper in Portsmouth is the Fowle building at the corner of Pleasant and Howard Streets. The *New Hampshire Gazette* was published by Daniel Fowle and his slave Primus with the help of other slaves. The *Gazette* published advertisements for slave sales and runaway slaves and the local ships' import information.
Courtesy of Michelle Arnosky Sherburne, Portsmouth Black Heritage Trail site.

Runaway Ads in the New Hampshire Gazette

May 11, 1764: "Ran-away—Negro Boy named Fortune, age 16, wearing a red jacket and canvas trousers."

On August 19, 1757, James Dwyer advertised a runaway: "a Negro man servant named Scipio, about thirty five Years old, about Five Feet Eight Inches high, well set, and of a yellowish complexion; had on one of his hands a Scar. Said Negro was born and brought up among the English; he understands Husbandry, mows well, and affects to be thought a Man of Sense."

Henry Sherburne's slave Cromwell, forty-five years old, ran away, and it was reported he was wearing "a blue cloth coat and breeches, and a scarlet cloth jacket with metal buttons."

The following was an ad for Pomp, owned by Ebenezer Sawyer of Wells: "N.B. said Negro before his Elopement precur'd a counterfeit pass changing his own Name and his Master."

Chapter 18
HISTORY REVEALED

James Wood Journal

One sentence in a nineteenth-century journal opened a door to a secret in Lebanon, New Hampshire. That line shed light on one man's willingness to help a fugitive slave on the run. Granted it could have been a one-time event or it could have been one of many times that this man was part of the Underground Railroad network.

In the 1990s, Steve Restelli of Barre, Vermont, made the discovery in an antique shop in New Hampshire. Among old books and papers, he found an 1862 journal with no name or address identifying it. "The year 1862 was inscribed on the cover and as I read the first few pages it seemed very detailed, well written and very fascinating. I then skimmed to the June 1ˢᵗ entry and immediately bought the book. It was this entry that proves to be of profound importance in documenting that the journal writer harbored a fugitive slave."

That entry was the key to the discovery of a fugitive slave receiving help in Lebanon. The entry was:

> *JUNE 1862, Sunday 1ˢᵗ*
> *Father, Mary, Margaret & Rebecca went to meeting with two carriages—*
> *rained a little last night and is raining moderately this evening—A fugitive*
> *slave? came here abt 10 o'clock this eve to stay all night. I fixed him a bed*
> *in wool room.*

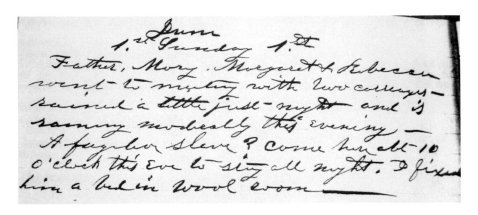

The June 1, 1862 entry of a Lebanon, New Hampshire farmer documents aiding a fugitive slave for the night. The journal was found in an antique bookstore by Steve Restelli of Barre, Vermont. Restelli had an Enfield historian research the unidentified journal and learned it was written by James Wood. *Courtesy of Steve Restelli collection.*

This was documented proof that a fugitive had been there. But where, and who helped? Restelli enlisted the help of an Enfield, New Hampshire historian and researcher, the late Richard Henderson, to solve the mystery of whose journal it was.

Henderson's research uncovered that the journal was written by James Wood of Lebanon, who was born in 1823 and died in 1895. He operated an eight-hundred-acre farm and lived with his parents, sisters, wife and children. The 1862 journal doesn't mention slavery, the Civil War or the abolitionist movement. The rest of his entries consist of typical farming content, including many entries relating to maple syrup production.

This entry about giving a fugitive shelter doesn't seem like a strange occurrence. Wood recorded searching for lost cows or a trip to town for supplies, with this fugitive entry falling in stride. There are no other references about helping fugitive slaves in letters or the series of journals Wood kept that his descendants have in their possession. The journal's importance is the documentation that a fugitive was aided by a New Hampshire person as far north as Lebanon.

James Wood, born and raised in Lebanon, operated a hay marketing business, an apiary with seventy-five colonies, a surveying business and a sheep farm. He sold bees and beekeeping supplies. The Wood farm is in the southeast part of Lebanon on the road known as the Croydon Turnpike, leading from Lebanon Village to Meriden.

Son's Saga Discovered in Letters

A descendant of John Coe, an abolitionist and Underground Railroad agent in Center Harbor, New Hampshire, came across a family story that involved slavery, a wayward son and a father's attempt to right the son's wrongs. Letters told the story of the son, John Coe Jr., who left his New Hampshire home and found himself in trouble from the East Coast to the West Coast. Because John Coe Sr. of Center Harbor was meticulous about recordkeeping, he made copies of every letter he sent and kept every receipt. Because of these documents being saved, the wayward son's story came to the surface in the twenty-first century.

John Coe Jr. built a bad reputation in his hometown before he was twenty-one and left for Lowell, Massachusetts. There, he was arrested on charges of conspiracy to defraud. His father had connections in Massachusetts and had a friend pay his son's bail. But John Jr. didn't want help and fled. John Jr. left the East Coast and changed his name to Rufus Ogden; his destination was California. The Coe family in New Hampshire disowned him.

California was where Rufus Ogden hoped to be a success, but instead he spent thousands of dollars and ended up in debt. He relocated to Natchez, Mississippi, and worked in a law office. Ogden established a home and owned six slaves. In 1855, he wrote a letter to his father, though they had severed ties. Ogden wrote about the yellow fever epidemic spreading in the West. Shortly after, at age twenty-four, Ogden contracted the disease and died.

John and Lavinia Coe learned of their son's death secondhand; a letter from his employer, Josephus Hewitt, was sent to Ann Coe Towle, John Jr.'s sister. The news was tragic, and another letter Ann received upset them further.

Ann, as Ogden's legal heir, received a letter from Richard, one of his slaves, who wrote: "It was your brother Mr. Ogdens wish that I should be set free in his death…my self and wife have since been sold. Now my Mistress if you could do anything for me I would pay you for my time. It is still in your power to free me and my wife from slavery."

The Coe family learned that Ogden had owned not just one but six slaves and that he also owed money on some of them. His parents were helping slaves to freedom while their son owned slaves out West. His father attempted to free the slaves through his political connections and then through mail correspondence to Natchez. Coe tried to use Ann Coe Towle's authority to free the slaves, but in Mississippi, the only way to free a slave was to buy or transport him or her to a free state.

Settling Ogden's estate dragged on, and by 1860, John Coe Sr. prepared for a trip west. Because tensions were so high across the country and he was going to a slave state, Coe armed himself with a passport from the New Hampshire governor and letters of recommendation so he could travel through the southern states safely. It was a three-thousand-mile journey to Natchez, and Coe arrived safely. No records surfaced showing that he purchased and freed Ogden's slaves. It has been accepted that he did all he could but was unable to free them and he had to give up. He returned home in August 1860. A year later, Coe died.

Lyme Balch Documents Saved and Revealed

Charlie Balch of Lyme is a descendant of Samuel Balch, who was an Underground Railroad agent. Charlie owns the houses that Samuel built. In these houses, Charlie found receipts, subscriptions paid to the New Hampshire Abolitionist Society and Lyme's Antislavery Society and a subscription to the *Abolitionist Standard* periodical. Samuel Balch was the treasurer of Lyme's Abolitionist Society, which was part of the New Hampshire Abolitionist Society. The documents had lists of people and the money paid for subscriptions, dated 1839, 1841 and 1842.

The documents were hidden by Samuel Balch because if they had been found during the Underground Railroad era, they would expose those people involved in antislavery societies and provide evidence of financial support for the abolitionist movement.

The Lyme documents in the Charles Balch collection include a document for dues paid to the New Hampshire Abolition Society by the Lyme Anti-Slavery members: "Lyme Anti Slavery Subscription: We, the undersign, hereby agree to pay into the Treasury of the New Hampshire Abolition Society, or to some one of its authorized agents, by the first of May 1841, the sums set against our several names. Lyme Dec. 21st 1840."

The amounts ranged from one to twenty-five dollars each. The names on the documents include men in town who were known to have worked together to move fugitives northward, including Irenus Hamilton, S.W. Balch, C.P. Fairfield, Moses Smith, C.B. Hamilton, Saml. R. Claflin and Selah Beals.

Another receipt for sixty-seven dollars was paid on February 6, 1841, to help aid the State Abolition Society. The treasurer of the Lyme Anti-Slavery

One of the Balch family documents was a list of subscribers to the *Abolition Standard* dated October 7, 1840. It reads: "$17 Received of Asa W Dodge seventeen dollars in payment for the *Abolition Standard* for one year beginning with Vol 1 No 7 for the following subscribers in Lyme NH: Pd 1.12 Philander Allen; David Steel; S W Balch; Ira Hewes; Danl Lancaster; Moses Smith; Dea A. Dimmick; Cal P. Turner; Geo Franklin; Freeman Josslyn Jr.; Eliphlet Kimball; Dea C P Fairfield; Cal A Southard; Royal Storrs; Caleb Bailey; Alanson Grant; Dea. I Hamilton. Young & Wirth. Concord." *Courtesy of Charles Balch private collection.*

Society was Samuel W. Balch, and the sixty-seven dollars was paid by Irenus Hamilton. Balch turned the money over to New Hampshire Abolition Society agent Alanson St. Clair.

One of the documents had a long list of Lyme residents and amounts they donated. The document stated, "We the under Signed agree to pay the Sum Set to our respective names to the Treasurer of the Lyme Anti Slavery

Society and to be appropriated by Executive Committee of the Society to aid the cause of Abolition of American Slavery as they in their Judgment may think best. Lyme Nov 6 1839."

In the membership totals for antislavery societies in New Hampshire, representatives registered their towns' society numbers. For Lyme, the representative was Irenus Hamilton in November 1836, and he recorded 244 members. Even with that many members, it was imperative to keep loyalties to groups like the state Abolition Society or a local chapter of the Anti-Slavery Society quiet.

Novel Written by African American Woman Discovered

There were limited copies published of H.E. Wilson's book *Our Nig; or, Sketches from the Life of a Free Black, in a Two-Story White House, North. Showing that Slavery's Shadows Fall Even There*, and it was not distributed much beyond the New Hampshire and Massachusetts areas. This fictional novel ended up on bookshelves, and Wilson's work faded into obscurity for decades. It also was unknown who "H.E." was. One original edition surfaced in the early 1980s in a Manhattan bookstore and was discovered by Henry Louis Gates Jr., a well-known American historian and journalist. Gates analyzed the novel written by "H.E. Wilson" and discovered that it had been written by Harriet Wilson, an African American woman, in 1859, predating the accepted first African American novel, published by Frances Ellen Watkins Harper in 1892.

Not only did it mark a historical first in this country, but Gates also determined that it was not fiction but autobiographical, telling Wilson's own story. Originally it was thought that a white person wrote the book. There were factors that contributed to it becoming lost in the stacks, including the sensitive themes of interracial marriage, abuse and racism in the North.

The extensive research of Gates was followed by that of P. Gabrielle Foreman, Reginald Pitts, JerriAnne Boggis, Valerie Cunningham, Eric Gardner, Barbara White, David Watters and others. Wilson's writing revealed her life and experiences struggling to survive alone in New England. Much historic detective work was conducted to make the connections between fictional characters and real people. The compilation

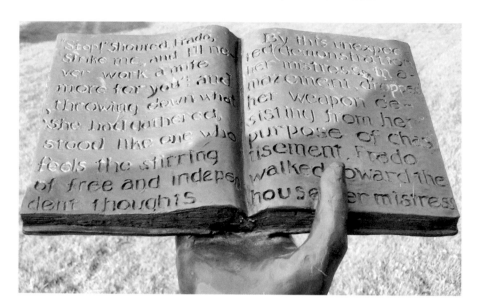

The Harriet Wilson statue, placed by the Harriet Wilson Project, is in Bicentennial Park in Milford, New Hampshire. This statue commemorates her life and novel, the first written by an African American woman in the United States. The page etched on the statue book pages states, "'Stop!' shouted Frado, 'Strike me and I'll never work a mite more for you'; and throwing down what she had gathered, stood like one who feels the stirring of free and independent thoughts. By this unexpected demonstration her mistress, in amazement, dropped her weapon desisting from her purpose of chastisement. Frado walked toward the house. Her mistress…" *Courtesy of Michelle Arnosky Sherburne.*

of that work was *Harriet Wilson's New England: Race, Writing and Region*, edited by JerriAnne Boggis, Eva Allegra Raimon and Barbara White.

Gates wrote in the foreword of that book: "Wilson's novel…showed us that slavery and racism existed in New England, just a short journey from Boston and Concord, those hotbeds of Abolition and freethinking that have long been considered the foundation of the American literary tradition. *Our Nig* turned my understanding of New England on its head."

Oliver Cromwell Gilbert

The life of Oliver Cromwell Gilbert took centuries to piece together and was perpetuated in a number of ways that finally came together in the research of Jody Fernald, archive librarian at University of New Hampshire, and Stephanie Gilbert, the great-great-granddaughter of the fugitive slave.

Oliver Cromwell Gilbert was etched in New Hampshire history as a runaway slave who spent two years with an abolitionist family in Lee. The local histories recorded his stay with the Moses Cartland family. A New Hampshire woman had a collection of papers that referred to Gilbert's stay. His existence was also etched in letters Gilbert wrote to abolitionists like William Lloyd Garrison, the Cartlands and the Rowell family. Gilbert had corresponded with his former owners' family, the Warfields in Maryland, and these letters were also preserved.

In 2009, a Philadelphia Gilbert descendant, Stephanie Gilbert, came across hidden keepsake boxes in a relative's home. She found paper, keys and notes of her ancestors. These were all pieces of the puzzle spread around different states but not allowing for the full image of Gilbert. It wasn't until 2011 that Stephanie Gilbert found Oliver Gilbert's fifty-two-page handwritten account of his life in an antique store in Philadelphia and all the pieces came together.

The Gilbert memoir confirmed Thaddeus Stevens's Underground Railroad activities, as well as Moses Cartland's in New Hampshire. Fernald and Stephanie Gilbert co-authored *Oliver Cromwell Gilbert: A Life* in 2014; it gives a well-rounded account of Gilbert's life as a slave, fugitive, abolitionist lecturer and freed man.

Part V

TWENTY-FIRST-CENTURY COMMEMORATIONS

Appendix 1

PORTSMOUTH BLACK HERITAGE TRAIL

Discover Portsmouth, operated by the Portsmouth Historical Society, encompasses the Portsmouth Black Heritage Trail, the John Paul Jones House and the Portsmouth Marine Society.

The Portsmouth Black Heritage Trail was established in 1995, and its mission is to preserve the history and culture of the African American

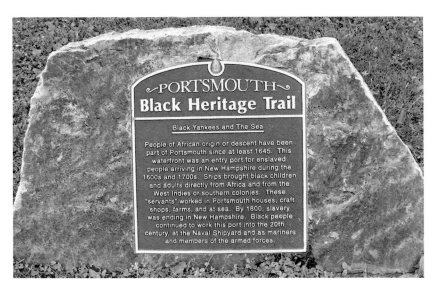

On the Portsmouth Black Heritage Trail, plaques like this one designate the sites. Known as black Jacks, enslaved and free blacks worked the ships and docks and went to sea. *Courtesy of Michelle Arnosky Sherburne, Portsmouth Black Heritage Trail site.*

community in Portsmouth and the New Hampshire region. It promotes awareness and appreciation of people of color through education and public programs. The mission is to share the stories of Africans and their descendants who have been a part of this region's history for over 350 years.

As of 2015, twenty-four Portsmouth Black Heritage Trail bronze plaques are visible at historic sites throughout the city. There are also self-guided tours and organized walking tours of the Portsmouth Black Heritage Trail. In conjunction with history awareness, Discover Portsmouth features a Sunday Tea Lecture series, a Spring Symposium and a Fall Black New England Conference. Educational resources are available online as well.

The director is JerriAnne Boggis, and a founding member is Valerie Cunningham.

For information about the Portsmouth Black Heritage Trail, go to www. portsmouthhistory.org or visit Discover Portsmouth at 10 Middle Street in downtown Portsmouth, New Hampshire.

Phone: (603) 436-8433

Hours: Open daily 10:00 a.m.–5:00 p.m., Fridays until 8:00 p.m., April 1– December 23

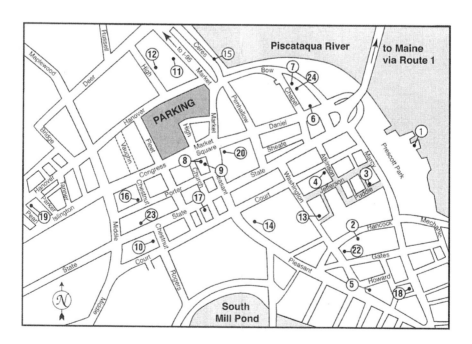

The official Portsmouth Black Heritage Trail map. *Courtesy of Portsmouth Black Heritage Trail Inc.*

PORTSMOUTH BLACK HERITAGE TRAIL SITES
(Sites that are in bold refer to slavery or Underground Railroad history)

1. **The Wharf at Prescott Park**
2. **Stoodley's Tavern, Hancock Street at Strawbery Banke**
3. **The Sherburne House at Strawbery Banke**
4. **William Pitt Tavern on Court Street at Strawbery Banke**
5. ***New Hampshire Gazette* Printing Office, corner of Pleasant and Howard Streets**
6. **Macphaedris-Warner House, corner of Daniel and Chapel Streets**
7. **St. John's Church on Chapel Street**
8. **North Church, Market Square**
9. **Town Pump and Stocks, Market Square**
10. **Negro Burial Ground on Chestnut Street between State and Court Streets**
11. **Moffatt-Ladd House, 154 Market Street**
12. **Whipple Home (private residence) Ground, High Street and North Burial, Woodbury Avenue**
13. **Samuel Penhallow House on Washington Street, Strawbery Banke Museum**
14. **Langdon House, 143 Pleasant Street**
15. **Waterfront, Ceres Street**
16. **Site of the Temple (now the Music Hall), Chestnut Street**
17. **South Church, 292 State Street**
18. South Ward Room, Marcy Street
19. People's Baptist Church, (now the Pearl), 45 Pearl Street
20. 14–16 Market Street (private offices)
21. Navy Yard, viewed from Prescott Park
22. Rosary's Beauty Shop, 171 Washington Street
23. Rockingham House, 401 State Street
24. St. John's Parish Hall, Chapel Street

THE HARRIET WILSON PROJECT'S BLACK HERITAGE TRAIL

I n 2005, the Harriet Wilson Project produced a history trail commemorating sites in Milford, New Hampshire, that were connected to the abolitionist movement, the Underground Railroad and the life of Harriet Wilson.

The site selection and information was compiled and edited by JerriAnne Boggis for the Harriet Wilson Project. For additional information on the sites or to arrange a group tour, contact the Harriet Wilson Project, 614 Nashua St. #121, Milford, NH 03055, (603) 494-4475, or visit www. harrietwilsonproject.org. The map and trail publication is available online.

Following is a brief summary of Black Heritage Trail sites in Milford:

EAGLE HALL: Eagle Hall was the first meetinghouse built in Milford. On January 4 and 5, 1843, Eagle Hall hosted an antislavery convention featuring famous abolitionists William Lloyd Garrison, Wendell Phillips, Parker Pillsbury, Nathaniel Peabody Rogers, Charles Remond, Abby Kelley Foster, Stephen Foster, George Latimer and Frederick Douglass.

FIRST CONGREGATIONAL CHURCH ON UNION STREET: In the 1800s, the First Congregational Church supported the antislavery movement. Several of its pastors—including the Reverend Ephraim Hidden (who officiated at Harriet Wilson's wedding)—were vocal and actively worked against the institution of slavery.

DISTRICT NO. 3 SCHOOLHOUSE ON OLD WILTON ROAD AND PHELAN ROAD: Harriet Wilson, who was indentured at the Hayward's, went to school at No. 3 from 1832 to 1834.

GEORGE BLANCHARD'S HOME ON MASON ROAD: Revolutionary War soldier George Blanchard, a black man, moved to Milford in 1804. He was a successful veterinary surgeon well known in southern New Hampshire and was succeeded by his son Dr. Timothy Blanchard. Researchers have thought Harriet Wilson was born on Blanchard's farm.

HAYWARD'S HOMESTEAD ON MAPLE STREET: Hayward Homestead is where Harriet Wilson served as an indentured servant.

ELM STREET CEMETERY: George Blanchard; his wife, Elizabeth; his sons John and George W.; and his grandsons Samuel and William are buried here.

SITE OF BOYLES HOME ON COTTAGE STREET: Samuel and Mary Boyles took in boarders and paupers, as stated in the 1850 federal census return for Milford that shows "Harriet Adams" (later Harriet Wilson) living at this address. Harriet Wilson researchers suggest that the Boyleses may have been spiritualists, a movement with which Wilson became involved in later life. The Boyleses' home was torn down in 1969 when the American Legion house was built.

LEONARD CHASE HOME ON HIGH STREET: Leonard Chase was a Garrisonian abolitionist and vice-president of the New Hampshire Anti-Slavery Society. His home was one of the stations on the Underground Railroad.

REVEREND HUMPHREY MOORE HOME ON ELM STREET: Reverend Humphrey Moore was the pastor of First Congregational Church, and his Elm Street home once had an underground passageway leading from the cellar toward the river. Tradition is that it was used as an Underground Railroad station.

HUTCHINSON FAMILY HOMESTEAD ON RIVER ROAD: Jesse and Polly Hutchinson had sixteen children, and thirteen became famous as the Hutchinson Family Singers. They were known not just as "performers," as the most famous antislavery newspaper put it, "but as abolitionists" as well.

OTHER SITES: Reverend Hidden's Home on Elm Street; North River Road Cemetery; Baptist church on South Street: In 1839, the Baptist church was the site of the Hutchinson Family Singers' first public concert; West Street Cemetery; Schoolhouse District Number 7; Milford Poor Farm; and Bicentennial Park, on South Street near Rail Road Pond, which was added to the list of Milford's parks in 1973. Work was completed on the three-acre park in 1975, and it was dedicated on July 27 as part of Milford's bicentennial celebrations. Bicentennial Park now is the home of the Harriet E. Wilson Memorial statue.

PORTSMOUTH AFRICAN BURYING GROUND

O ctober 7, 2003, will be a day Portsmouth will never forget. During water-sewer project construction on Chestnut Street, the crew unearthed a historic discovery that had been hidden since the 1800s. Crumbling wooden coffins were discovered under the street. It was discovered that a black burying ground existed on the site. Thirteen coffins were discovered, and officials were called in. The state archaeologist worked with a team to remove eight coffins, but five burial sites were left untouched. Checking earlier city maps, a "Negro" cemetery had been documented up until the 1800s, when the cartographers eliminated it from future maps.

Valerie Cunningham, a prominent black historian and the founder of Portsmouth Black Heritage Trail, Inc., said, "This literal unearthing of New Hampshire's black history not only provided concrete proof of a black history in the state, it highlighted a corresponding history of white indifference to black life and death, an indifference that once allowed real estate development to proceed over sacred burial ground."

Research and DNA testing on eight of the remains was conducted, and it was determined they were of African descent. Further research of maps showed that as many as two hundred graves could be in the Chestnut Street vicinity.

Initially, Portsmouth City Council created the African Burying Ground Committee in 2004 with members of the community and representatives of Seacoast African American Cultural Center and the Portsmouth Black Heritage Trail, Inc., to work on the memorial project. In August 2005, Portsmouth City Council approved a partial street closure of Chestnut Street.

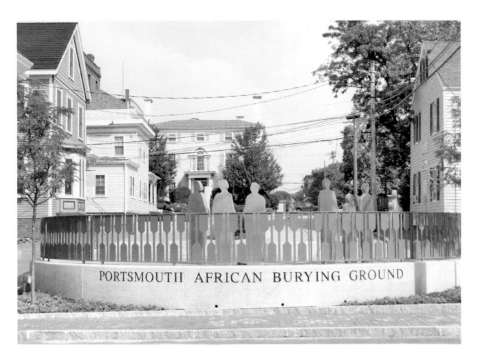

Portsmouth African Burying Ground Memorial. *Courtesy of Michelle Arnosky Sherburne, Portsmouth Black Heritage Trail site.*

Through the years, the African Burying Ground Committee worked on plans for a memorial. Jerome Meadows, a sculptor from Savannah, Georgia, was commissioned to create the African Burying Ground Memorial.

In August 2014, consecration of the African Burying Ground site took place and the memorial construction began. Meadows worked diligently, and the committee enlisted the help of Portsmouth Middle School students to design 112 tiles that were incorporated into the design. On May 23, 2015, the Portsmouth African Burying Ground reburial ceremony was held, followed by a community celebration opening the memorial to the public.

At the memorial park, there are two entry figures on the State Street end. The male figure stands for the first enslaved Africans brought to Portsmouth and those who followed. The female figure represents Mother Africa.

The petition line leads from the entry figures monument all the way to the memorial. The petition line is made of red granite and is engraved with phrases from the 1779 petition for freedom written by twenty enslaved men asking the New Hampshire legislature for an end to slavery.

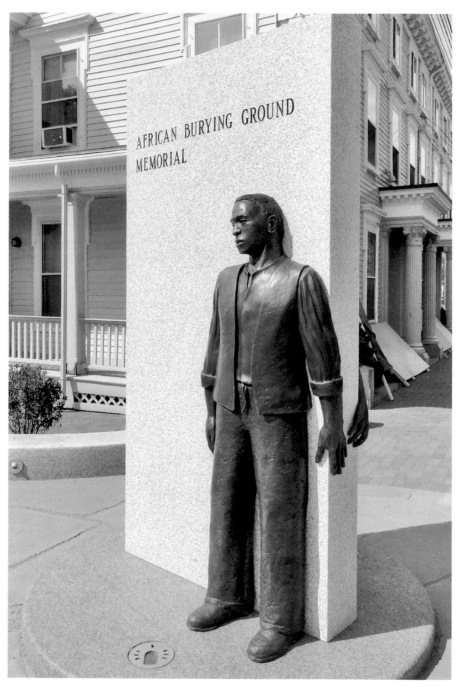

The entrance statue of the Portsmouth African Burying Ground off State Street in Portsmouth. *Courtesy of Michelle Arnosky Sherburne, Portsmouth Black Heritage Trail site.*

The burial vault lid is formed by a shield and cover with an Adinkra figure *Sankofa*, meaning "return and get it, learn from the past." The vault contains the reinterred remains of those eight Africans exhumed and partial remains found at the site in 2003.

The decorative railing around the memorial at the Court Street end is based on an African kente cloth motif symbolizing boat paddles.

The community figures are life-sized bronze silhouettes that represent the collective community of Greater Portsmouth gathered to resolve to acknowledge, protect and pay homage to the souls whose remains were uncovered here in 2003. Each figure bears a line from the poem by sculptor Jerome Meadows, inspired by this sacred place:

> *I stand for the Ancestors Here and Beyond*
> *I stand for those who feel anger*
> *I stand for those who were treated unjustly*
> *I stand for those who were taken from their loved ones*

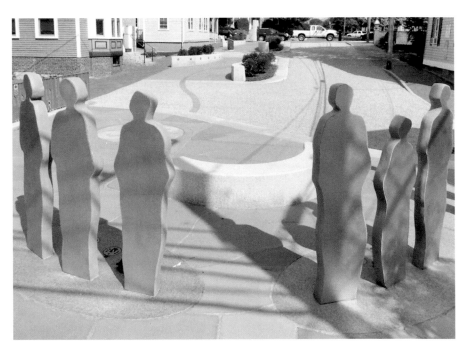

Long shadows fall over the Portsmouth African Burying Ground Memorial that was opened in May 2015. Thirteen coffins were unearthed during a water-sewer project, and now the lives of thousands of slaves in Portsmouth are honored by this memorial. *Courtesy of Michelle Arnosky Sherburne, Portsmouth Black Heritage Trail site.*

I stand for those who suffered the middle passage
I stand for those who survived upon these shores
I stand for those who pay homage to this ground
I stand for those who find dignity in these bones.

African Burying Ground, Chestnut Street between Court and State Streets, Portsmouth, NH 03801, (603) 610-7226. For more information, go to www. africanburyinggroundnh.org or visit them on Facebook.

BIBLIOGRAPHY

American Revolution Bicentennial Committee. *Underground Railroad Sites in New England*. N.p.: Courier Printing Company, 1975.

Bell, Charles Henry. *History of Exeter NH*. N.p., 1888.

Bemis, Charles Austin. *History of the Town of Marlborough, Cheshire County, NH*. N.p.: Geo. Ellis, Publisher, 1881.

Bittinger, Reverend J.Q. *History of Haverhill, NH*. N.p., 1888.

Blaisdell, Katharine. *Over the River and Through the Years Book 3 and 5*. From the *Journal Opinion*, Bradford, VT, and Woodsville, NH. 1981 and 1983.

Boggis, JerriAnne, Eve Allegra Raimon and Barbara White. *Harriet Wilson's New England: Race, Writing and Region*. Lebanon: University of New Hampshire Press, 2007.

Bouton, Nathaniel. *History of Concord, 1725–1853*. N.p.: Benning Sanborn, Publisher, 1856.

Brewster, Charles. *Rambles of Portsmouth*. Series 1 and 2. N.p., 1873.

Brighton, Ray. *Port of Portsmouth Ships and the Cotton Trade, 1783–1829*. N.p.: Portsmouth Marine Society, Peter E. Randall, Publisher, 1986.

Center Harbor Historical Society. *Center Harbor New Hampshire 15th Anniversary 1971–1986*. N.p., October 2011.

Cheney, Emeline Burlingame. *The Story of the Life and Work of Oren B. Cheney*. Lewiston, ME: Bates College, Morning Star Publishing, 1863; repr., Charleston, SC: BiblioLife, n.d.

Cole, Luanne. *Patterns and Pieces, Lyme, New Hampshire 1761–1976*. N.p.: Lyme Historians Inc., Phoenix Publishing, 1976.

Cutter, Daniel. *History of the Town of Jaffrey, New Hampshire*. N.p., 1881.

Fernald, Jody. *In Slavery and in Freedom: Oliver C. Gilbert and Edwin Warfield Sr.* Lebanon: University of New Hampshire, n.d.

Fernald, Jody, and Stephanie Gilbert. *Oliver Cromwell Gilbert: A Life*. N.p.: University Library Scholarship, 2014. scholars.unh.edu/library_pub/75.

Fillion, Robert. *Haverhill, Flower of the Coos, Its History*. N.p.: Haverhill Heritage Books, 1999.

Hammond, Isaac W., ed. and comp. *Petition of Slaves, 1779 in New Hampshire. The State of New Hampshire—Miscellaneous Provincial and State Papers, 1725–1800. Published by Authority of the Legislature*. Vol. 18. N.p., 1890.

Horton, Louise, Elizabeth Underhill and Eleanor Deal. *Piermont, New Hampshire 1764–1947*. N.p.: Piermont Committee, Green Mountain Press, n.d.

Jackson, James. *History of Littleton, NH*. 3 vols. Cambridge, MA: University Press, 1905.

Jewell, Elizabeth. *Franklin: Then & Now*. Charleston, SC: Arcadia Publishing, 2008.

Lakeway, Mildred. *Historic Glimpses of a North Country Community: Littleton, New Hampshire*. N.p., n.d.

Lambert, Peter. *Amos Fortune: The Man and His Legacy*. N.p.: Amos Fortune Forum, 2000.

Lauritsen, Eric. *The Untold Story of New Hampshire and the Transatlantic Slave Trade, 1700–1800*. Hanover, NH: Dartmouth Press, 2009.

Lord, John King. *A History of the Town of Hanover, NH*. Hanover, NH: Dartmouth Press, 1928.

Lyford, James O. *History of Concord, New Hampshire*. Vol. 2. N.p.: City History Commission, 1896.

Pillsbury, Parker. *Acts of the Anti-Slavery Apostles*. N.p., 1883.

Ramsdell, George, and William Colburn. *The History of Milford, New Hampshire*. Milford, NH, 1901.

Salerno, Beth A. *Sister Societies: Women's Antislavery Organizations in Antebellum America*. DeKalb: Northern Illinois University Press, 2005.

Sammons, Mark J., and Valerie Cunningham. *Black Portsmouth: Three Centuries of African-American Heritage*. Lebanon: University of New Hampshire Press, 2004.

Siebert, Wilbur H. *Underground Railroad: From Slavery to Freedom*. N.p., 1898.

Smith, Albert. *History of the Town of Peterborough*. N.p.: Press of George Ellis, 1876.

Stearns, Ezra. *History of Plymouth, NH*. N.p., n.d.

Wallace, William A. *History of Canaan, NH*. N.p., n.d.

Whitcher, William F. *History of the Town of Haverhill, NH*. N.p., 1919.

Wilder, Craig Steven. *Ebony & Ivy: Race, Slavery and the Troubled History of America's Universities*. London: Bloomsbury Press, 2013.

Wilson, Harriet E. *Our Nig; or Sketches from the Life of a Free Black*. Introduction by Henry Louise Gates Jr. and Richard J. Ellis. 1859; repr., New York: Vintage Books, Random House, 2011.

Yates, Elizabeth. *Amos Fortune, Free Man*. New York: Puffin, Penguin Group, 1950.

Unpublished Works

Cheesborough, Jerald. "Colonial New England through the Eyes of the Black Slave: Debunking the Myth of Racial Inferiority in the 18th Century." Available at www.academia.edu.

Hughes, Paul. "A Pleasant Abiding Place." Unpublished manuscript, Weeks Public Library Collection, Greenland, NH.

Rogers, Daniel Farrand. "Autobiography of Daniel Farrand Rogers." Unpublished memoir, Michael J. Spinelli Jr. Center for University Archives and Special Collections, Herbert H. Lamson Library and Learning Commons, Plymouth State University, gift of Sarah Kinter of Canterbury, NH, 1998.

Websites

African American Registry. www.aaregistry.org.

Andover Historical Society. www.andoverhistory.org.

Aten, Carol Walker. "A Brief History of African-Americans in Exeter." www.exeterhistory.org.

Cow Hampshire: New Hampshire's History Blog. www.cowhampshireblog.com.

Dartmouth's Rauner Blog: "In the Shadow of the Ivory Tower." November 5, 2013. raunerlibrary.blogspot.com.

Exeter Historical Society. www.exeterhistory.org.

Feeney, Toni. "1790 Census: Slave Holders, Other Free Persons and Slaves—Cheshire County, New Hampshire." sites.google.com/site/1790censusot herfreepersons.

Genii: The Conjurors' Magazine. www.geniimagazine.com.

George Washington's Mount Vernon. "Research & Collections." www.mountvernon.org/research-collections.

The Liberator Files. www.theliberatorfiles.com.

Lyme Historians. lymehistorians.wordpress.com.

National Park Service. www.nps.gov.

New England Music Scrapbook. www.reocities.com/nemsbook/home.htm.

Newspapers.com. www.newspapers.com.

North Sandwich (NH) Monthly Meeting of Friends (Quakers). northsandwich.quaker.org.

Nutfield Genealogy. nutfieldgenealogy.blogspot.com.

Old Maps. www.old-maps.com.

Reino, Roni. "Going Back in Time: Years Later, Woman Traces Steps of 1848 Slave Relative to Lee." May 5, 2011. fosters.com,

Rimkunas, Barbara. "The Question of Slavery." *Exeter News-Letter*, "Historically Speaking" column, March 15, 2013. exeterhistory.blogspot.com.

RootsWeb. www.rootsweb.ancestry.com.

Scoundrels Forum. scoundrelsforum.com.

Scribd.com. www.scribd.com.

Seacoast NH: America's Smallest Seacoast. www.seacoastnh.com.

Slavery in the North. slavenorth.com.

Stern, George. "On Holidays in Germantown, Then and Now." December 24, 2013. freedomsbackyard.wordpress.com.

University of New Hampshire. "Center for New England Culture." cola.unh.edu/center-new-england-culture.

Voyages: The Trans-Atlantic Slave Trade Database. slavevoyages.org.

Wikipedia. www.wikipedia.com.

Newspaper and Magazine Articles

Adams, Reverend T.H. "Washington's Runaway Slave." *Granite Freeman* [Concord, NH], May 22, 1845.

American Revolution Bicentennial Underground Railroad Sites in New England, 1976.

Bean, Margaret. "Jaffrey's Fortunes." *New Hampshire Premier*, August 1993.

Chase, Reverend Benjamin. "Slave Testimony: Two Centuries of Letters, Speeches, Interviews, and Autobiographies." *Liberator*, January 1, 1847.

Clark, Edie. "Finding Venus." *Yankee Magazine*, February 1999.

Dunbar, Erica Armstrong. "George Washington, Slave Catcher." *New York Times*, February 16, 2015.

Griswold, Gabrielle. "A Story of Slavery in the White Mountains." *New Hampshire Lakes and Mountains*, March 2010, online version.

Guay, Victoria. "Underground Railroad Revealed Coe House Helped Many Flee Slavery." *The Citizen*, September 2010.

Heyduk, Dan. "Following John Coe." *Meredith News*, n.d.

Latour, Francie. "New England's Hidden History." *Boston Globe*, September 26, 2010.

NHMagazine. "The Strange Case of Abolitionist John Coe and His Prodigal Son." February 2011.

Oedel, Howard. "Slavery in Colonial Portsmouth." *Historical New Hampshire* 28, no. 3 (Autumn 1966).

Plymouth Record Enterprise. Black History Month articles. February 21, 2008.

Roberts, Aria. "Birthplace of Abolitionist Movement in New Hampshire." *Plymouth Record*, June 3 1954.

Salisbury, Stephan. "A Slave's Defiance: The Story of Rebellious Oney Judge." *Philadelphia Inquirer*, July 1, 2008.

Zerillo, Chris. "America's Stonehenge." *NHToDo Magazine* 1 (Spring 2004).

Collections

Charles Balch personal collection, Lyme, NH.

Center Harbor Schoolhouse Museum, Center Harbor Historical Society Collection, Center Harbor, NH.

Haverhill Library, Haverhill, NH.

Michael J. Spinelli Center for University Archives and Special Collections, Herbert H. Lamson Library and Learning Commons, Plymouth State University, Plymouth, NH.

Historical New Hampshire Magazines, New Hampshire Historical Society.

Hood Museum of Art, Dartmouth College, Hanover, NH.

Jaffrey Public Library, Amos Fortune Collection.

Liberator, William Lloyd Garrison collection.

Littleton Public Library, Littleton, NH.

Lyme History Museum, Lyme Historians, Lyme, NH.

New Hampshire Gazette.

Rauner Special Collections, Dartmouth College, Hanover, NH.

Steve Restelli personal collection, Barre, VT.

Wilbur H. Siebert Underground Railroad Collection, Ohio Historical Society, www.ohiomemory.org.

Donna Zani-Dunkerton private collection, Canaan, NH.

Nonprofit Historic Points of Interests in Portsmouth

America's Stonehenge, North Salem, New Hampshire. stonehengeusa.com.

Discover Portsmouth, 10 Middle Street, Portsmouth. www.portsmouthhistory. org (also location for Portsmouth Black Heritage Trail).

Governor John Langdon House, 143 Pleasant Street, Portsmouth. Historic New England, HistoricNewEngland.org.

Moffatt-Ladd House and Garden, 154 Market Street, Portsmouth. National Society of the Colonial Dames of America in the State of New Hampshire. www.moffattladd.org.

Portsmouth African Burying Ground Memorial, State and Chestnut Streets, Portsmouth. For tour visit Seacoast African American Cultural Center, 10 Middle Street, Portsmouth. www.AfricanBuryingGroundNH.org.

Strawbery Banke, 14 Hancock Street, Portsmouth. www.strawberybanke.org.

Warner House, 150 Daniel Street, Portsmouth. www.warnerhouse.org.

INDEX

ABOUT THE AUTHOR

Originally from Pennsylvania, Michelle Arnosky Sherburne's family moved to Vermont in 1976. Her father is Jim Arnosky, a nationally renowned children's book author/illustrator, so Michelle grew up around authors, editors, artists and basically the publishing field.

She has been a writer since high school and started working for a weekly newspaper two days after graduating from high school. In the business for over 30 years, she is now the production manager at the *Journal Opinion* in Bradford, Vermont, a 150-year-old community newspaper. She has freelanced for magazines and newspapers since the 1990s, finding that history features are her strength.

Photo by Lillian Gahagan.

Michelle has been married for twenty-eight years and lives with her husband and son in Newbury.

Michelle hit the bookshelves initially with the award-winning *A Vermont Hill Town in the Civil War: Peacham's Story*, for which she volunteered two years to work with the Peacham Historical Association. She published *Abolition & the Underground Railroad in Vermont* as her first solo book with The History Press in 2013. She followed that in 2014, researching and writing in a two-and-a-half-month stretch the book *The St. Albans Raid: Confederate Attack on Vermont*, which premiered at St. Albans' 150th celebration of the raid.

She enjoys sharing history with area schoolchildren and gives lectures at libraries, museums, historical societies and organizations around Vermont, New Hampshire and New York.